MEDIÆVAL LONDON

By

WILLIAM BENHAM

And

CHARLES WELCH

First published in 1901

This edition published by Read Books Ltd.
Copyright © 2019 Read Books Ltd.
This book is copyright and may not be
reproduced or copied in any way without
the express permission of the publisher in writing

British Library Cataloguing-in-Publication Data
A catalogue record for this book is available
from the British Library

CONTENTS

A Short Introduction to the History of London..........vii

CHAPTER I ...1

CHAPTER II ..22

CHAPTER III..36

CHAPTER IV..49

CHAPTER V ..64

CHAPTER VI..76

INDEX..79

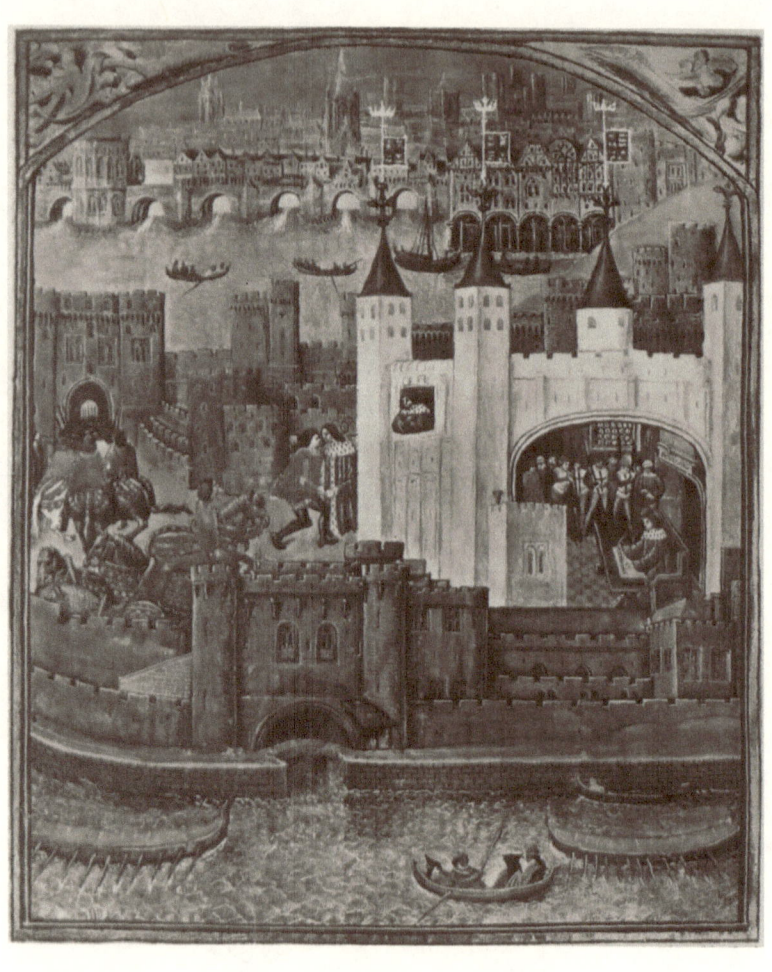

ILLUSTRATIONS

LONDON BRIDGE AND THE TOWER. From a Manuscript of the Poems of Charles, duke of Orleans. British Museum, 16 F. ii. *Frontispiece*

A TOURNAMENT. From a Manuscript of the Romance of the Sire Jehan de Saintre. British Museum, Nero D. ix. *P.* 10

RICHARD II. RIDING OUT OF LONDON TO THE WAR IN IRELAND. From a Manuscript of Froissart's Chronicles. British Museum, Harl. 4380. *P.* 18

RICHARD II. DELIVERED BY BOLINGBROKE TO THE CITIZENS OF LONDON. From a Manuscript of the Metrical History of Richard II. British Museum, Harl. 1319. *P.* 34

THE FUNERAL OF RICHARD II. From a Manuscript of Froissart's Chronicles. British Museum, Harl. 4380. *P.* 74

THE PRINCIPAL PARTS OF A PEN DRAWING OF LONDON FROM WESTMINSTER TO GREENWICH, BY ANTONIE VAN DEN WYNGAERDE. Bodleian Library, Oxford.

Of this Flemish artist very little is known. There exists a rescript of Philip II. addressed to Margaret of Parma, regent of the Low Countries, giving him permission to remove with his goods and to settle in Spain, from which it is supposed that he was in the King's service. The drawing was made, probably for Philip, before the fall of the spire of St. Paul's in 1561. It is unfinished, blank spaces being left for Whitehall, Bridewell, and some other buildings. There are also memoranda on the drawing which show that the artist intended to colour it, leaden roofs, for instance, being marked " blau." The Bodleian Library possesses forty-seven other drawings of his, two of which are here reproduced: one of Whitehall, intended no doubt to fill the blank space in the large view, and one of Greenwich Palace from the Observatory Hill, which is coloured in a simple manner. It is not improbable that Wyngaerde left England on the death of Queen Mary. A copy of the drawing of London, much altered and embellished, was made and engraved by N. Whittock in 1849.

 WESTMINSTER TO CHARING CROSS.
 THE STRAND.
 ST. PAUL'S CATHEDRAL.
 LONDON BRIDGE.
 BILLINGSGATE AND ST. MARY SPITAL.
 THE TOWER.
 GREENWICH PALACE, FROM THE THAMES.
 GREENWICH PALACE, FROM THE OBSERVATORY HILL.
 THE PALACE OF WHITEHALL.

DRAWINGS BY JOHN WYKEHAM ARCHER. British Museum.

John Wykeham Archer (b. 1808, d. 1864), a water-colour painter, engraver, and antiquary, was employed by another antiquary, Mr. W. Twopeny, more than half a century ago, to make twenty drawings yearly of London antiquities, a work which he carried on until his death. Many of the buildings which he drew have since been destroyed, or have undergone restoration. The whole collection was acquired for the British Museum, and fills seventeen portfolios. A very few of the drawings were etched by Archer for his book entitled *Vestiges of Old London*.

ROMAN BATH IN THE STRAND. 1841.
BASTION OF THE CITY WALL IN THE CHURCHYARD OF ST. GILES'S, CRIPPLEGATE. 1841.
THE CRYPT OF GUILDHALL. 1842.
THE CRYPT OF ST. MICHAEL'S, ALDGATE. 1841.
THE CRYPT OF MERCHANT TAYLORS' HALL.
GARDEN HOUSE, CANONBURY, BUILT BY THE LAST PRIOR OF ST. BARTHOLO-MEW'S, SMITHFIELD. 1841.
AUSTIN FRIARS. 1842.
A CELL IN THE LOLLARDS' TOWER, LAMBETH. 1841.
ENTRANCE TO THE LOLLARDS' TOWER. 1841.
THE GUARD ROOM, LAMBETH. 1841.
THE CRYPT OF ST. STEPHEN'S, WESTMINSTER. 1842.
GATEWAY OF THE BLOODY TOWER. 1847.
MACHINERY FOR RAISING THE PORTCULLIS, TOWER OF LONDON. 1850.
WARDERS' LODGINGS, TOWER OF LONDON. 1847.

The coloured Illustrations are printed by Mr. Edmund Evans *at the Racquet Court Press.*

A SHORT INTRODUCTION TO THE HISTORY OF LONDON

London has been a major settlement since being founded by the Romans, who named it Londinium, two thousand years ago. As the capital city of England, it is also the country's most populous city, with its metropolitan area housing over thirteen million inhabitants and taking the crown of the most visited city in the world. At the centre of this, now gargantuan metropolis, is an area known as the City of London, covering only 2.9Km 2 – still contained within its medieval boundaries. Due to this peculiar quirk of history, 'the City of London' actually qualifies as the smallest city in England.

The first sizable conurbation appeared in the region in 43 AD, but only lasted seventeen years until it was ransacked and burned by the Iceni tribe led by Queen Boudica. Its next incarnation was more successful when in the second century AD it acted as the capital of the Roman province of Britannia – its population then swelled to sixty thousand. This settlement survived until the fifth century when it was largely abandoned due to the collapse of the Roman Empire. It was then the turn of the Anglo-Saxons to become the dominant force in the area, building it up into a major trade port by the mid seventh century. This success became very difficult to maintain as the following centuries found London's inhabitants having to defend themselves against an onslaught of Viking invasions and their subsequent occupation of much of the east and northern parts of England.

The City continued to grow throughout the Middle Ages, for the most part after the Battle of Hastings in 1066 AD and the conquest of the Normans. William, Duke of Normandy,

was crowned in the newly finished Westminster Abbey and consolidated his presence by ordering the construction of the Tower of London and Westminster Hall. Over the next hundred years the central government of England became fixed in the area of the City of Westminster while the City of London, its neighbour, flourished into England's most populous city (as well as its commercial centre). This district grew and grew until the disastrous onset of the Black Death in the mid fourteenth century.

The Black Death resulted in a third of the City of London's inhabitants being lost to the pandemic. It was estimated to have killed over one hundred million people throughout Europe. This however, was not to be London's only catastrophe. The Great Plague of 1665 which killed 100,000 people was immediately followed by the Great Fire of London in 1666. This particularly devastating blaze swept through the central parts of the city, destroying many of the predominantly wooden buildings, all in all resulting in the loss of 13,200 houses, 87 parish churches, St. Paul's Cathedral and most of the city authority's buildings. The destruction was on a large scale, but London was not to be broken. Under the supervision of the surveyor Robert Hooke, a rebuilding programme was ordered and the city underwent a ten year period of reconstruction.

In the wake of this rebuilding some of the city's most iconic buildings and areas appeared, such as St Paul's Cathedral and the district of Mayfair. This bustling capital city became a hub for both business and culture, and the place to be for forward thinking academics. The famed scholar Samuel Johnson (1709-1784) once commented:

'You find no man, at all intellectual, who is willing to leave London. No, Sir, when a man is tired of London, he is tired of life; for there is in London all that life can afford.'

During the Victorian era London became the world's largest city as it gradually expanded to join up with the surrounding counties who operated under the banner of the London County Council. It was seen as a city of progress, and thousands flocked

to be a part of the industrial and economic development. This sudden enlargement led to paralysing traffic congestion however, which required a novel solution. This resulted in the construction of the world's first underground rail network, a shining example of the engineering prowess of a nation on the up. Despite such success stories, the twentieth century brought with it a new adversary to deal with, the air raid. Although significant bombardments were made in the First World War, it was the Second World War that saw the catastrophic potential of this new aerial technology. The German Luftwaffe killed over thirty thousand inhabitants and reduced large tracts of the city to rubble. Before the war London reached its peak population at around 8.6 million in 1939, but following the conflict its numbers fell to an estimated 6.8 million in the 1980s.

London continues to be a hugely influential, cosmopolitan capital, and remains a hive of cultural innovation. It has a long and multi-faceted history and it is hoped that this brief introduction has inspired the reader to find out more.

MEDIÆVAL LONDON

CHAPTER I.

A COMPREHENSIVE SURVEY.

What are the Historical Limits of "Mediæval London?"—Derivation of "London"—The Roman City—Outlying Districts—Decay of Ancient London—Renewal after the English Conquest was Complete—London Christianised—King Alfred's London—Its Gradual Rise to Supremacy—St. Paul's Cathedral—William the Conqueror's London—London in the days of the Plantagenets.—Foundation of Westminster Abbey—Rebuilt by Henry III.—St. Clement Danes—Watling Street—The Folkmote Ground—Cheapside and its Surroundings—The Pageants—The Arches Court—London Wall, the Gates and Towers—City Trees—The Religious Houses — Monasteries — Priories—Colleges—Hospitals — Episcopal Residences—London Outskirts—Notes of Remarkable Events under the Successive Dynasties—Aggas's Map of London, temp. Queen Elizabeth.

MEDIÆVAL LONDON—it is a perfectly distinct and real subject, though it might be difficult to give exact dates of beginning and end. Historical periods glide in, and run their course, and fade away or take fresh shape. Yet we may venture to approximate, and to say with some confidence that Ancient London changed into Mediæval in the days of King Alfred, and passed into Modern with the accession of the Stuarts. The Great Fire of 1666 made vast changes not only in the city itself, but in the surroundings thereof, but modern London had begun nearly a century before that.

London is not mentioned in Cæsar's account of Britain, but we know from Tacitus that it existed and was a place of importance. In a lecture of Dean Stanley delivered in Exeter Hall, entitled "The Study of Modern History in London," he follows the etymology accepted in his time, and interprets the name "The City of Ships." That derivation was disproved by Dr. Guest, and the meaning now, so far as I know, universally held by scholars is "The Fortress by the Lake."

The "lake," so called, was the river spread out in a wide marsh on the Surrey side, and the "fortress" was a palisaded ground round the neighbourhood of the present Cannon Street Station. When the Romans took possession in the first half of the first century, they fortified it with a tower and a wall. Parts of the Roman wall are still standing; most of it remained in the days of Mediæval London. Substantial fragments of the later wall taken from around Bishopsgate are preserved in the Guildhall Museum. They include portions of handsome Roman buildings and sculptured ornaments. Evidently some, having fallen into decay, were in the course of ages used by mediæval Londoners for the repairs of their walls. And there are further remains of elaborate furniture, and other proofs of high civilised life in London. But the written history of the city during the Roman occupation is a blank. It was certainly the largest port in the country, but of written records there are none. Traditions there are of visits of Apostles and other Christian missionaries, and one church in the city has a brass plate stating that it stands on the site of the mother church of London, the foundation of King Lucius. But this is a sheer myth, King Lucius and all. That during those years of Roman dominion there were Christian congregations we may feel confident, but there are no proofs. Beyond the city were swamps and marshes on all sides. A dreary tract covered with reeds and thorns, and formed into an island by a river which came down from the hills and enclosed it by forking off into the Thames, is now occupied by the fair City of Westminster. I myself can remember when a large part of Belgravia still consisted of fields. A somewhat eccentric Hertfordshire baronet, who seconded the Reform Bill of 1832, once brought up a bag fox and a pack of hounds, and hunted him through those fields. The swamp continued all the way to Fulham on the west, and over Finsbury on the north. Beyond the marshes all round rose a region of thick, well-nigh impenetrable forest.

The departure of the Romans was followed after a brief interval by the English Conquest, and London decayed—we may even say fell into utter desolation. For her greatness had been entirely commercial; she had had large trade with the Continent, which was now broken to pieces. She had received her food from ships which came both up and down the Thames, but the poor Britons who were fighting for existence had no

more to send her. The rich traders and merchants had no longer any occupation, and left their luxurious homes to find it elsewhere. And so the once flourishing London became deserted.

But when the English Conquest was accomplished, and peace for a while followed warfare, a population also reappeared in London, consisting of traders who saw the great advantages of its situation. Prosperity began to return. London became once more a city of merchants. It was again flourishing when the heathen English were converted to Christianity by Augustine, so much so that in 604 one of his companions, Mellitus, became its first bishop, Sebert being then king. Sir Walter Besant sees in the identity of the Cockney dialect ("lydy" for lady, &c.) with that of Essex, a proof that the new population were chiefly from the East Saxons.

At first the Christianising of London seemed to be a failure. Mellitus built a cathedral, but had to flee before the heathenism into which the king's sons relapsed. The failure, however, was but temporary, and the Church became altogether triumphant. The intense sense of nationality, which has always characterised the English people, comes out in the names given to the London churches. The greater number of them were dedicated to English saints, and the names continue to this day. One of these saints—Botolph—who had endeared himself immensely to the Londoners, went forth to N.E. England and established a great mission there, and there he died. The noble tower of Boston (= Botolph's town) preserves his memory in Lincolnshire. But the Londoners, in love and veneration to his memory, built churches bearing his name at all the four gates which led towards his burial-place; three of them still remain, and the name of the fourth survives in Botolph's Lane, by Billingsgate.

When King Alfred had delivered the country from the Danish invaders and restored peace, he put forth his energies to strengthen London and enlarge its prosperity. It had been growing almost uninterruptedly, while it had been subject, now to one of the kingdoms of the Heptarchy, now to another. Alfred made it really the chief city of his dominion. Winchester in some respects was held to be the royal city, but London became in fact the capital of England. It was the richest and the most influential city. Under the Danes, on their

second invasion, it retained its influence, and added at least two churches with Danish names, Olaf and Magnus.

Mediæval London had thus begun, but still the recorded details of its history for a while are scanty; and there are few remains of Saxon London either. The first cathedral of Mellitus, probably of wood, was burned in 961; so was its successor in a great fire of 1084. There are here and there a few Saxon churches remaining in England, such as Bradford-on-Avon in Wilts, and Corhampton in Hants. It is not to be wondered at that there is not one in London, though there were then many. Maurice, whom William the Conqueror made Bishop of London, began a new cathedral in 1086, of course in the usual Norman style, with round arches and heavy pillars, such as may still be seen in the transepts of Winchester. But two hundred years passed before it was completed, and as it was always the custom in the Middle Ages to carry on building, or to make repairs and restorations, in the style of architecture in vogue at the moment, St. Paul's became, like nearly all our English cathedrals, a composite building, exhibiting not only Norman, but Early English and Early Decorated. This cathedral was enclosed by a wall in which were six gates. The names of two of these are preserved in the names of "Paul's Chain" and "St. Paul's Alley."

London's importance became more and more fully established. She had struggled successfully for her rights against the Danish King, Cnut. London from the first stood high in favour with the Conqueror. It had not resisted him, and he remembered that, and lost no opportunity of showing his gratitude. The city had hitherto struggled between adversity and prosperity, but the Norman brought her halcyon days, and from his time her greatness was assured. In the Guildhall Charter-room is a manuscript beautifully written, six inches by one inch, and this is what it contains:—

CHARTER OF WILLIAM I. TO THE CITY OF LONDON.

"Will'm kyng gret Will'm bisceop and Gosfregð portirefan, and ealle þa burhwaru binnan Londone, Frencisce and Englisce freondlice. and ic kyde eow þat ic wylle þat get beon eallra þæra laga weorðe þe gyt wæran on Eadwerdes dæge kynges. and ic wylle þæt ælc cyld beo his fæder yrfnume. æfter his fæderdæge. and ic nelle geþolian þæt ænig man eow ænig wrang beode. God eow gehealde."

Of which document the following is the translation:—

"William the king greeteth William the bishop and Godfrey the portreeve, and all the burgesses within London, French and English, friendly. And I acquaint you, that I will that ye be all those laws worthy, that ye were in King Edward's day. And I will that every child be his father's heir, after his father's day. And I will not suffer that any man do you any wrong. God preserve you."

It is a very intelligible piece of worldly wisdom to have to note, that he followed this charter up by building "the White Tower," the chief feature in our imposing fortress, the Tower of London. In the year 1100, his son, Henry I., gave the city a fresh charter, distinctly enumerating the privileges of the citizens, which had been hitherto merely prescriptive; and he granted to the Corporation the perpetual Sheriffwick of Middlesex.

But the greatest instance of the influence which London displayed, and which she has ever since exerted on the national history, was the fact that in the fierce contest for the crown, between Stephen of Blois and Matilda, it was the citizens of London who decided the question in favour of the former. By that time the population of the city had received a very large foreign element. Not only Danes, but Normans and Gascons had been welcomed with readiness and admitted to full citizenship. Of course the Norman Conquest had done this. The rich merchants of Rouen and Caen were a strong acquisition to London commerce. It was the Norman element which turned the scale in the contest for the crown, and there were two causes which operated on the Normans. Matilda had married Geoffry, count of Anjou, and there was a traditional jealousy between the Normans and Angevins. But further, the Londoners were now under the spell of a strong religious movement to which I shall have presently to refer, and the Angevin princes already bore, and continued to bear, the character of blasphemers of God and His Church.

Mr. J. R. Green vividly points out how, on the vacancy of the throne, the Londoners, in the absence of noble and bishop, now claimed for themselves the right of election. "Undismayed by the want of the hereditary counsellors of the Crown, their aldermen and crier-folk gathered together the folk-mote, and these providing at their own will for the good of the realm, unanimously agreed to choose a king. The

very arguments of the citizens are preserved to us as they stood massed doubtless in the usual place for the folk-mote at the east end of Paul's, while the bell of the commune rang out its iron summons from the detached campanile beside. 'Every kingdom,' urged alderman and prudhomme, 'was open to mishap, where the presence of all rule and head of justice was lacking ! It was no time for waiting ; delay was in fact impossible in the election of a king, needed as he was at once to restore justice of the law.' But quick on these considerations followed the bolder assertion of a constitutional right of pre-election, possessed by London alone. '*Their* right and special privilege it was, that on their king's death his successor should be provided by *them* ;' and if any, then Stephen, brought as it were by Providence into the midst of them, already on the spot. Bold as the claim was, none contradicted it ; the solemn deliberation ended in the choice of Stephen, and amidst the applause of all, the aldermen appointed him king."

It will be convenient to pause at this point to look at the great change which had taken place westwards. The stately Abbey of Westminster had arisen on what was once a thorny waste. Originally founded by Sebert, the first Christian King of the East Saxons, it had been rebuilt by King Edward the Confessor in the Norman style, of which he was the real introducer into England. It was consecrated only a week before his death, January, 1066, and the ill-fated Harold was crowned in it immediately after, as was William the Conqueror before the year had ended From that day to this Westminster Abbey has been the scene of the Coronation of all the English monarchs. Later on, Edward the Confessor was canonised, and his remains were removed from their original resting-place, and laid in a stately shrine prepared by Henry II., who was present, along with his Chancellor and Archbishop Becket, at the " translation." This was on the 13th of October, 1163. It was in consequence of the honour thus conferred upon it that the Abbey was declared by the Pope exempt from the jurisdiction of the Bishop of London, and subject only to the authority of the Pope and the King of England. Its Abbot was " mitred," *i.e.*, he was privileged to wear the Episcopal habit, and to claim a seat on the Episcopal bench in the House of Lords.

The thirteenth century saw a yet further honour for the Abbey. Henry III., who always held the memory of Edward the Confessor in

"prodigious value" (which he showed by naming his eldest son after him), resolved on rebuilding the Abbey in the beautiful style which we commonly call "Early English," though he had seen it in France, and at once became, not unreasonably, enamoured of it. The present beautiful church is, in large measure, his work, though later abbots continued it: the material additions since have been the Lady Chapel, commonly known as Henry the Seventh's, he being the founder, and the western towers, by Sir Christopher Wren, at a date outside our limits. It is hard to realise, until one has seen similar buildings on the Continent, that there was a partition wall entirely dividing the choir, which belonged to the monks, and the nave, to which the general congregation was admitted. This wall was removed in the time of Henry VII.

The road between London and Westminster passed amidst detached houses and farms. The monks of Westminster cultivated their produce in the Convent Garden—the name lives on, though the "n" in the first word is gone. After the peaceable settlement of the Danes, a portion of territory was set apart for them to dwell in between London and Westminster. As they were seafarers, they naturally took the sailor's saint for their patron, and the church which they built for themselves is known to us as St. Clement Danes.

But it is time to return to our City. We have seen that the Cathedral of St. Paul's was now a noble building, worthy of the capital of the kingdom. The Bishop lived on the north side of the Cathedral, his palace and gardens extended back to Paternoster Row; the chapter house, and the cloisters round it, lay on the south side of the nave; fragments of it may be seen to this day. Adjoining the S.W. wall of the nave was the church of St. Gregory-by-St. Paul. The parish still exists. In that church the body of St. Edmund, King and Martyr, lay for some years before it was buried at the town which bears his name. On the east side of the churchyard was a large grass-grown space, just such a spot as we still see so constantly on the borders of country towns and villages—the "village green," in fact. Across it came the great Roman road, which started from London Stone, passed along what we now call Newgate Street, and went away to Cheshire, following, as we may say, the course of the N.W. Railway. This, after Roman times, received the name of Watling Street, *i.e.*, "Atheling Street" (= High Street). It does

not, indeed, so far as the city is concerned, answer to the present Watling Street, for after leaving what we call Budge Row, which was part of it, it went straight on over ground which is now covered with the streets south of Cheapside. It became necessary, later on, to change its course, owing to difficulties connected with the enlargement of St. Paul's Churchyard, and the new Watling Street is the substitute. But to return to the "Green" by St. Paul's. This, after Norman times, was the site of the Folkmote, of which the present "Common Council" are the elected representatives. The citizens met on this green in the open air, seats being plentifully dispersed about, and here the public business of the city was carried on. Nor must we omit mention of "Paul's Cross," at the east corner of the north transept of the Cathedral, the site of which was discovered by Mr. Penrose, and is now marked by an inscription on the ground. At the east end of the green there was a short, narrow street, passing through which you came (just where is the fine plane-tree) into Cheapside. But it will tax the imagination of the reader considerably to realise how different was this locality from that which bears the same name to-day. "*Side*" means "place," or "part." Cheapside means, therefore, "Market-place." It was as much the London market-place as that of any provincial town of to-day. It was a large square, reaching back as far as the present Honey Lane, and other streets in a straight line with it, and with booth-decked streets branching away as far as the Guildhall and Basing Hall.

Here, then, we have the two centre places of Old London: the Cathedral, with its ecclesiastical surroundings (a large, populous, and important district in itself), and the Chepe, into which, north and south, ran streets, the names of which indicated the nature of the commerce carried on there. Thus there was Bread Street, where the bakers congregated, and to which were brought the supplies of corn landed from the river close by, having been conveyed thither chiefly from the great cornfields which covered the whole Isle of Thanet. The name of St. Mildred's Church in this street is a relic of the respect paid to her as being the tutelary saint of that bread-growing island. Ironmonger Lane, Wood Street, Milk Street, and the Poultry tell their own story. Budge Row was so called because here were sold robes of Budge, a kind of fur, for Aldermen and other public officers. Milton talks of the "budge

doctors." Friday Street, in close contiguity with St. Paul's and some of the other great religious houses, was so called because it was devoted to the sale of fish for fast-days, &c. At a later time it became necessary to have an additional market-square, and it was found in the *East Cheap*.

All through the Plantagenet times, the "golden age of chivalry," the great square of "the Chepe" was the scene of tournaments and martial pageants. Adjoining the church of St. Mary-le-Bow was a scaffold projecting into the street, which it was the privilege of Royalty and the courtiers to occupy on such occasions. Once, in the reign of Edward III., a sad accident occurred by the falling in of this scaffold, whereby some not only of the occupants, but of the spectators in the street beneath, were killed. It is said that the King, with true Plantagenet violence, ordered the head carpenter to be hanged, and was turned from his purpose, as at Calais, by the intercession of the Queen. It led to an alteration. The Royal gallery was firmly fixed to the wall of the church, and so remained. Years later, after the Great Fire, when Wren rebuilt the church, and surmounted it with its present beautiful spire, there was a stipulation that there should be a "Royal gallery." And there it is still, the passer-by can see it from the street. I doubt whether Royalty in our time has ever mounted into it, but it is an historical relic of the ancient pageants of Cheapside.* Nor is this the only relic of the past in that church. In ancient times there was a great chamber, resting on arches, in the tower, and the church was called the Church of *Sancta Maria de Arcubus*; hence its present name of "St. Mary-le-Bow." That chamber was the rightful possession of the Archbishop of Canterbury, who held it as his court for the trial of ecclesiastical causes brought before him as Metropolitan. Hence came the title of "Court of *Arches*," the Spiritual Court of the Metropolitan. Strangely altered as the office has become in the course of years, it still exists; the judge of ecclesiastical cases is still known as "the Dean of Arches." And when this St. Mary's Church was rebuilt after the Fire of 1666, Wren placed its magnificent spire on an arched base—a memorial of the ancient ecclesiastical dignity.

* One of the "properties" still remains in Ironmongers' Hall, an ostrich on which a black boy was seated in a seventeenth-century Mayoralty pageant. The beautiful drawings of Anthony Munday's "Chrysanaleia," a pageant prepared for Sir John Leman's Mayoralty procession in 1616, are preserved at Fishmongers' Hall.

We are now in a position to look back, and take a comprehensive survey of our great city in the Middle Ages.

First. We have the Tower on the east side, guarding the approach from the sea, and the high and spacious wall surrounding the whole city. Fitzstephen, a monk of Canterbury, gives an interesting picture of the times of Henry II. He describes London as bounded on the land side by a high and spacious wall, furnished with turrets and double gates. These were Aldgate, Bishopsgate, Cripplegate, Aldersgate, Newgate, Ludgate, and probably Bridgegate. But see Stow's comment (Ed. Thoms, 1842, page 11). There was also a postern near the Tower. The latter he calls "the Tower Palatine," and also names "two castles well fortified" in the west, Baynard and Montfichet. The former stood at the western extremity of the city wall on the site of the present Castle Baynard Wharf, and adjoining Carron Wharf. The name survives also in the name of "Castle Baynard Ward." It was built by Baynard, a follower of William the Conqueror, and though it was burnt more than once, it was duly restored, and lasted till the Great Fire. It became a Royal palace, and in it Edward IV. assumed the title of King. Henry VIII. made it one of his residences. So did Edward VI., on whose death Queen Mary was here proclaimed Queen. Montfichet Tower was between the site of Ludgate Hill Station and Printing House Square. A bastion of the London Wall still remains in the churchyard of St. Giles', Cripplegate.

Secondly. The great market-place—the Cheap—with the principal streets all leading into it, represents the commercial magnitude of the city. The residences of the merchants and traders had, for the most part, each its garden, large or small. It is a commonplace saying that there is not a street in London from some part of which you cannot see a tree. This was more true a few years ago than it is to-day. Thus, there was a beautiful plane-tree in front of Grocers' Hall, in Princes Street, but exigencies of building-space led to its destruction but lately. Cheapside still rejoices in its fine tree at the corner of Wood Street, which has found a great poet to write pleasantly about it. Down in secluded streets the London saunterer comes on more of these trees, relics of old citizens' gardens and resorts, as well as those in closed churchyards. The parish of St. Martin Pomeroy preserves in its second name the memory of the ancient orchard which once gladdened the Londoner's eyes.

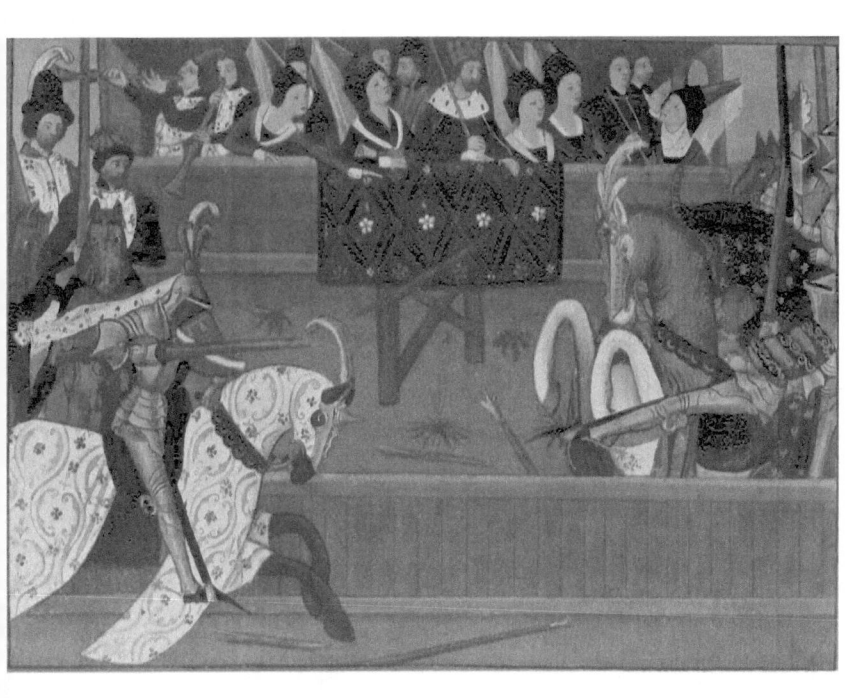

Then, *thirdly*, there were the Religious Houses. Fitzstephen says that in his day (*temp.* Henry II.) there were thirteen conventual churches and 126 parochial. Some were of pre-Norman times, like the Collegiate Church of St. Martin's-le-Grand, founded by one Ingelric in 1056, and confirmed by a charter of William the Conqueror in 1068. Though this stood in the heart of the city it was independent of civic control; the Mayor and Corporation often endeavoured in vain to exercise authority over it. Criminals on their way to execution now and then managed to slip within its boundaries, in which case they were safe in sanctuary. It was from this church that the Curfew Bell for London tolled out each evening, a signal for closing the city gates, as well as the taverns.

An event of vast importance in the religious life of this nation was the great Cistercian movement in the beginning of the twelfth century. This is not the place to tell the history of the origin of it, the mighty endeavour to reform the decadent Benedictine order made by Robert of Molesme, who settled himself in the hamlet of Citeaux (Cistercium), near Dijon, and set up the first reformed monastery. The movement soon found its way to England, the first Abbey being founded at Waverley, near Farnham; and before long it had its devotees in London, the most noteworthy of whom was Gilbert Becket, a wealthy trader in Cheapside. It was the excitement of this which was upon the Londoners when, as we have already had to note, they chose Stephen for king against the supposed irreligion of the House of Anjou. Under the influence of this religious revival a new impulse seemed to come upon the Church, which bound it closer than it had ever been before in the affections of the people. Gilbert Becket's son, Thomas, became known to the Archbishop of Canterbury, Theobald, for his intense religious earnestness, became his right hand in administration, guided him unfalteringly through the troubles which came out of the dreadful civil war between Stephen and Matilda, and finally gave peace to distracted England. How the eager young Londoner himself became Archbishop, and how he came for many a year to be regarded as the very chief of English saints, we need not tell here. And this new religious impulse told in the city to the extent of changing its very aspect. The Cathedral which Bishop Maurice had begun seemed for a while to be languishing. Now barges came up the

river with stone from Caen for the great arches which excited the popular wonder. Rahere, the king's minstrel, raised his noble Priory of St. Bartholomew in Smithfield, of which enough still remains to make it the finest Norman building in London. Alfune, in 1090, built St. Giles's, Cripplegate. The dissolution of the Cnichten Guild (a body of thirteen knights as old as King Edgar, which continued to hold land on fanciful tenures down to 1115) was followed by the bestowal of their property on the Priory of the Holy Trinity in Aldgate, and out of this arises an interesting episode. The first prior, Norman, built his cloister and church, and bought books and vestments on so liberal a scale that there was nothing left to buy food. The citizens, visiting the place on Sundays according to custom, saw that the poor canons were famished with hunger. "Hic est pulcher apparatus, sed panis unde veniet?" exclaimed somebody. "It is a fine show to be sure; but where is the bread to come from?" The women present, Becket's mother among them, vowed to send a loaf every Sunday, and soon there was enough and to spare. Very pretty is the story of the early life of the future martyr, how his mother, Rohese, used to weigh him on each birthday, and send money, clothes, and provisions, according to his weight.

The Cistercian is the first of the great religious movements which have wrought an enduring effect upon our national life. The Crusades, which have also left their mark in London, made a second; and within the period we are considering we have also to place the preaching of the Friars, the Lollardism of Wyclif, and the Reformation. Later on, past mediæval times, came the Puritan Rebellion, the preaching of the Wesleys, the Oxford Tract Movement, and the work of F. D. Maurice and the "Broad Church."

But it will be well to set down in order the principal religious establishments which grew up with the years. Here is a list of them as they existed at the time of the Reformation:—

FRIARIES AND ABBEYS.—*The Black Friars* (Dominicans) between Ludgate Hill and the Thames, extending from St. Andrew's Hill to the Fleet River. Their house was founded by Hubert de Burgh, earl of Kent, in 1221. It had a church and precinct with four gates. In this church Archbishop Courtenay was condemning the writings of Wyclif, when "a great earthquake shook the city." Here

Charles V. lodged when he was visiting Henry VIII. The latter king held a Parliament here, but transferred it to the house of the Black Monks of Westminster, hence it was called "the Black Parliament." At the Dissolution the church was given to the parishioners (St. Anne's, Blackfriars). The *Grey Friars* (Franciscans) had a noble house on the site of what is at this moment, though it will soon cease to be, Christ's Hospital. Parts of the old buildings remained as late as 1820 (see *Gentleman's Magazine*, May, 1820), indeed, there is a small portion even now. The noble church of the *Augustinian* (Austin) *Friars* (founded in 1253) still exists off Broad Street, the nave being used by the Dutch Protestant Church. The *White Friars* (Carmelites) had their church east of the Temple, founded 1241. It was pulled down at the Dissolution, and houses were built on the site, but it still preserved the right of sanctuary, and was consequently a haunt of thieves and fraudulent debtors. The privilege was not abolished till 1697. The *Crutched* (= crossed) *Friars*, so called because they wore a cross on their backs, had their church on the site of St. Olave's, Hart Street; the *Carthusians*, on that of the Charterhouse; the *Cistercians'* New Abbey was in East Smithfield; and the Brethren *de Sacca*, or "Bonhommes," were a small community under Augustinian rules in Old Jewry.

Then there were the PRIORIES, religious houses subject to greater abbeys or religious bodies. That of St. John of Jerusalem, at Clerkenwell, was founded in 1100 by Jordan Briset and his wife Muriel, and was endowed in 1324 with the revenues of the dissolved English Knights Templars. Its ancient gateway remains, the only one left of all the old London monastic houses. In the Wat Tyler rebellion (1381) the prior was beheaded in the great courtyard, now St. John's Square. Of the Priory of Holy Trinity, Aldgate, we have already spoken, as we have also of St. Bartholomew's, Smithfield, the noble chancel of which priory is still one of the finest buildings in London. Across the river the beautiful church of the Augustinian Priory of *St. Mary Overy* was built by Giffard, bishop of Winchester, in 1106, at the expense of two Norman knights. At the Dissolution, Henry VIII. gave it to the parishioners of Southwark for their parish church, and the name was changed to that of St. Saviour. How part of it tumbled down; how

it was rebuilt in Brummagem Gothic; how this also, happily, went to pieces, and has been replaced within the last few years by a handsome restoration, we all know.

Of NUNNERIES, we note St. Helen's, Bishopsgate, the church of the Priory of the Nuns of St. Helen, founded in 1212 by " William the son of William the Goldsmith." The church formerly had a partition dividing the nuns' portion from that of the parishioners. It was taken down at the Dissolution, but plenty of remains of the old arrangement are still evident in the church, which is in many features one of the most interesting in London. Until the year 1799 the old Hall of the nunnery was standing, having been bought by the Leathersellers' Company at the Dissolution for their Hall. *Holywell*, Shoreditch, was so called from a sweet well there, which was spoiled as the population came to increase in that part. There was here a Benedictine Nunnery, dedicated to St. John Baptist, founded in 1318 by Gravesend, bishop of London. In later days the famous Curtain Theatre was built on the site, which again has given place to St. James's Church, Curtain Road. Edmond, earl of Leicester, brother of King Edward III., founded an Abbey of nuns of the Order of St. Clare, commonly called the Minorites, in 1293, in a street between Aldgate and the Tower. On the Dissolution, Henry VIII. gave the chapel to the people for a parish church (Holy Trinity, Minories); the rest of the site was built over. The Benedictine Nunnery of St. Mary, Clerkenwell, was contiguous to the Hospital or Priory of St. John. The name Clerkenwell (*Fons Clericorum*) was derived from a well, at which once a year the Parish Clerks of London assembled and performed a religious play. It was at the S.E. corner of Ray Street. A pump marked the site until less than fifty years ago, when the water was found to be so polluted that it was removed. When the "Black Nunnery" was dissolved, the site was given to the Earl of Aylesbury, hence the present Aylesbury Street, Clerkenwell.

Of COLLEGES, *i.e.*, communities of religious men, were (1) *St. Martin's-le-Grand* (already mentioned); (2) *St. Thomas of Acon* (alias Acre), a military sanctuary founded by Agnes, the sister of St. Thomas Becket, over her brother's birthplace. It was on the site of the present Mercers' Hall, and was much regarded by the Corporation of London in the Middle Ages. Richard Whittington, Mercer, thrice

Lord Mayor (last time, 1419), founded the College of "Saint Esprit and Mary," in the Vintry Ward, and the Almshouse for Mercers. The site still bears the name of College Hill. Mercers' School was removed from hence to Barnard's Inn, Holborn, a few years since. The College of St. Michael, Crooked Lane, was founded by Sir William Walworth, who was buried within the church. This church was removed to make room for the approach to new London Bridge, in 1831.

Of HOSPITALS, note *St. Giles's-in-the-Fields* for Lepers, founded by Matilda, queen of Henry I.; *St. James's Hospital* " for leprous maidens," now St. James's Palace; *St. Mary of Rounceval*, a priory of the Abbey of Roncevalles in Navarre. It stood on the site of Northumberland Avenue at Charing Cross. *Elsing Spital*, by Cripplegate, was founded by Wm. Elsing in 1329, for the sustentation of a hundred blind men. The site was afterwards occupied by Sion College; but when that was moved to the Thames Embankment the ground was built over. Sir John Pountney founded and endowed a College in his own house in Candlewick Street, calling it *Corpus Christi*, to maintain a master and twelve mission priests. Their chapel was attached to the Church of St. Lawrence Pountney, which was burnt in the Great Fire and not rebuilt. The *Papey*, a house for worn-out priests, was in Bevis Marks. *St. Bartholomew the Less* is now the Chapel of St. Bartholomew's Hospital precinct. The *Lock Spital* was for the reception of lepers, the derivation being *loques*, rags. The old Hospital of *St. Katharine's by the Tower* was removed, in 1828, to make room for St. Katharine's Docks, and set up anew by the Regent's Park.

Episcopal Residences were those of the Archbishops of Canterbury and York, at Lambeth and Whitehall respectively; of the Bishop of Durham (Durham House, Strand); of those of Bath, Chester, Lichfield, Llandaff, Worcester, Exeter, Carlisle, all in the Strand; of Hereford, on Fish Street Hill. The Bishop of Ely dwelt in Ely Place, Holborn: the chapel still exists, in the possession of the Roman Catholics. Readers of Shakespeare will remember how the bishop grew strawberries in his garden. The Bishop of Salisbury's house was in Salisbury Square; of St. David's, near Bridewell; of Winchester and Rochester, in Southwark. Parts of Winchester House still exist there.

As the Thames on the south side of the city did noble service as the principal highway for its commerce and its corn supply, so the fields on the north furnished large pasture-land for its cattle. Across these fields a road led away to the village of Islington. In the Moor Fields were the Artillery Butts, whither young London resorted to be trained in the use of the bow. Readers may remember the description of them in the opening portion of Lord Lytton's novel, *The Last of the Barons*. Within the walls adjacent to this part the manufacturers of bows and arrows were settled. Very strange and curious have been the various associations of the name "Grub Street." Grobes were feathers for arrows, and originally Grub Street was that in which arrows were finished. That manufacture died out, and the street, being in a Puritan neighbourhood, in the days of Elizabeth became the publishing place for violent attacks upon the bishops. "Martin Marprelate," the well-known series of that class of publication, was issued from this street. Then, by a natural transition, scurrilous lampoons in general, and not merely theological, came to be called "Grub Street tracts," because the phrase had become current; and the name stuck, and was applied to literary rubbish of any kind, Pope having endorsed the title in his satire. The name has, unfortunately, disappeared from the street within the last decade. The authorities, because the name had become obnoxious to fastidious ears, have changed it to Milton Street, the poet having been borne down it from Bunhill Fields, where he died, to be buried in St. Giles's Church.

Partly on the site of Liverpool Street Station, and partly across the road as far as the Underground Railway, stood, in mediæval times, the "Hospital of St. Mary of Bethlehem." From early times, certainly in 1402, this religious foundation was devoted to the care of the insane, and at the Dissolution it became one of the Royal Hospitals, with lunatics exclusively for its inmates. It was the Great Fire of 1666 which permanently changed all this neighbourhood. Up to that time the greater part had been fields, but now the poor burned-out citizens came and (literally) pitched their tents here, and stowed within them the goods which they had been able to save. Here they carried on their business, and gradually substituted rough houses for these tents; and thus, by the time the City was rebuilt, a new suburb had arisen, and

a well-inhabited suburb from that time it remained. Bethlehem Hospital was removed to London Wall in 1675-6, as the monastic buildings had decayed, and the increasing number of patients required larger room. It found its present home in St. George's Fields in 1812-15. And here we may note that "Finsbury Fields," *i.e.*, Finsbury Circus and the land round it, formed the favourite summer lounge of the London citizens up to the beginning of the eighteenth century. It was laid out in formal style, with paths and bordering trees. Merchants and tradesmen came hither at eventide, as the fashionable world of to-day goes to Hyde Park. Poets and pamphleteers met publishers, and playwrights made appointments with managers. A large body of spectators frequently gathered here to see a thief whipped at the cart's tail.

And now we will simply name the most prominent events in the history of the city during our period.

In Pre-Norman times, after Alfred had restored the lost prosperity of London, his grandson Athelstan (925-940) established a royal palace and a royal mint, and gave an impulse to the commerce of the city by promising patents of gentility to every merchant who should make three voyages to the Mediterranean in his own ship. His "redeless" grandson Ethelred abandoned London to the Danes, and Cnut levied an impost of 11,000*l.* upon it, a proof of the great wealth which it had now acquired. It was a seventh part of that of the whole kingdom.

NORMAN TIMES.—As already mentioned, London is not in Domesday book. It is probable that there was a separate survey, the records of which are now lost. Domesday incidentally mentions ten acres of land near Bishopsgate, Norton Folgate, as belonging to the Dean and Chapter of St. Paul's, and a vineyard in Holborn, the property of the Crown.

The founding of the many religious houses during this period we have already mentioned. The building of the first stone bridge by Peter of Colechurch, which also belongs to this period, finds its place in another page.

We note the orders of Henry Fitzailwin, the first Mayor, for the prevention of fires. All houses were to be of brick or stone, with party walls of the same, and to be covered with slates or tiles. The building of houses round the Walbrook, Oldbourne, and Langbourn

had diminished the supply of water, so they sought a fresh supply from Tyburn, and supplied a conduit in Cheapside with water from thence, which they brought in leaden pipes (A.D. 1255). The chronicles of Evesham say that in 1258, 20,000 persons died of hunger through a scarcity of corn, and ghastly stories are told of another famine in 1270. But on the whole London increased and prospered under Norman rule. In 1264 there was a massacre of the Jews on some trivial pretext. They were expelled the kingdom in 1291.

PLANTAGENET TIMES.—The division of the city into wards dates from the beginning of this period or earlier. In 1348 came the terrible Black Death. "In London it was so outrageously cruel that every day at least twenty, sometimes forty or sixty, or more, dead corpses were thrown together into one pit, and the churchyard not sufficing for the dead, they were fain to set apart certain fields for additional places of burial.... But especially, between Candlemas and Easter in 1349, there were buried 200 corpses per diem" (Barnes's *Hist. of Edward III.*). It is chronicled that more than 50,000 persons were buried, during this pestilence, within the precincts of the Charterhouse alone. The trial of Wyclif in St. Paul's was a memorable event, when John of Gaunt stood forth as his champion.

In 1380 came the Wat Tyler rebellion, and the death of the leader from the dagger-stroke of Sir William Walworth. Hence the long-exploded but hard-dying theory of the "dagger" in the City Arms. The charge in question is the sword of St. Paul, London's patron saint, and it was borne on the City shield before the deed of Walworth. Smithfield, where the event took place, was then "a great plain field, without the gates," where on every Friday was "a great market for horses, whither earls, barons, knights, and citizens repair, to see and to purchase." Our quaint illustration depicts King Richard II. going forth on his ill-fated expedition against Ireland.

LANCASTER AND YORK.—The first recorded illumination of the City was at the Coronation of Henry IV. Ten years later, the Mayor, Sir Henry Barton, ordered that the streets should be lit with lanterns every night.

Jack Cade's rebellion in 1450 seemed at first successful, so far as the city was concerned. He took possession of it, and for a while

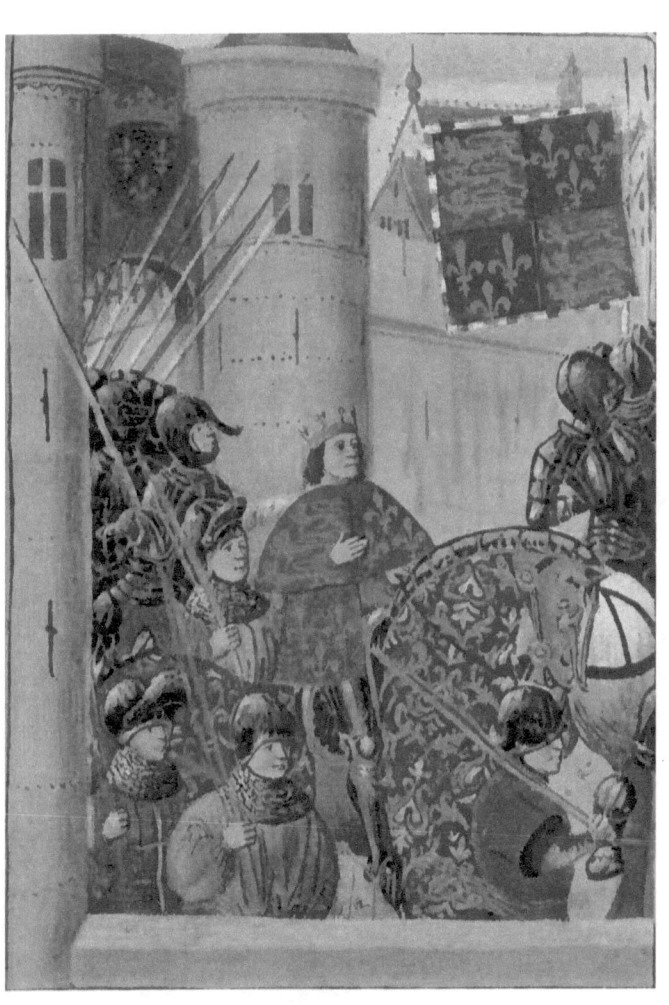

maintained order among his followers. But they broke out into outrages, slew Lord-Treasurer Saye, and other persons of consequence, and the citizens, with the assistance of the Governor of the Tower, rose up and expelled him. Soon afterwards he was killed. As a rule the citizens inclined to the House of York, and in consequence Edward IV, steadily favoured the Londoners. The setting up of Caxton's printing-press in his reign was a great epoch in the history of the world.

TUDOR PERIOD.—Two Lord Mayors and six Aldermen died of the sweating sickness in the first year of Henry the Seventh's reign. The citizens, as we have already noted, had been accustomed to practise archery north of the city. A regular field was enclosed for them in 1498 in Finsbury, which was the origin of the present Artillery ground. The river Fleet was made navigable as far as Holborn Bridge, and Houndsditch was arched over. Henry VIII. built the royal palaces of St. James's and Bridewell. Stricter rules were made for the preservation of order, nuisances were removed, and the streets were widened and paved. The first Act for the pavement and improvement of London describes the streets as "very foul and full of pits and sloughs, very perilous and noyous, as well for all the King's subjects on horseback as well as on foot and with carriages."

We should note the sumptuary law passed by the Mayor and Common Council in 1543 by which the Mayor was ordered to confine himself to seven dishes at dinner or supper; the Aldermen and Sheriffs to six; and the Sword-bearer to four.

In the reign of Edward VI. the hospitals of St. Thomas, St. Bartholomew, and Christ were founded, and the palace of Bridewell was also converted into a hospital. The borough of Southwark was constituted a ward of the city.

Passing over the terrible martyr-fires of Smithfield in the days of Mary, we come to the reign of Elizabeth, a very prosperous one as far as London was concerned. The refugees from Alva's cruelties in the Netherlands found a home in London, and did wonders for the improvement of its manufactures. There were, as elsewhere, extravagances in the way of spectacles and tournaments, and much opportunity was seized to flatter Gloriana, who was nowise averse thereto. It was apparently looked upon as always the correct thing, to flatter sovereigns. The

Preface to the Authorised Version of the Bible and Bacon's Dedication of his *Advancement of Learning* will be sufficient illustrations of this. Here is the inscription to a monument to Queen Elizabeth, which was put up in the Church of All Hallows the Great in Dowgate:—

"Spain's rod, Rome's ruin, Netherlands' relief,
Heaven's gem, Earth's joy, World's wonder, Nature's chief.
Britain's blessing, England's splendour,
Religion's nurse, and Faith's defender."

In the neighbouring Church of St. Michael, Crooked Lane, the same year, was set up the following inscription. The contrast is refreshing:—

"Here lieth, wrapt in clay,
The body of William Ray.
I have no more to say."

Soon after the accession of Elizabeth, Ralph Aggas published a very curious plan and view of London, with the title *Civitas Londinensis*. It reveals how much of field and garden there was then in the very heart of the city. The most crowded part was from Newgate Street, Cheapside, and Cornhill to the river. With the exception of Coleman Street, and a few scattered buildings from Lothbury to Billingsgate and from Bishopsgate to the Tower, all (N. and E.) was open or garden ground. Whitechapel was a small village; Houndsditch, a single row of houses opposite the city walls, opened behind into the fields; Spitalfields, from the back of the church, lay entirely open; Goswell Street was known as the road to St. Albans; St. Giles's was a small cluster of houses, known then, as indeed it is still, as "St. Giles's in the Fields." Beyond, all was country, both N. and W., Oxford Street having trees and hedges on both sides. As late as 1778 a German writer on London speaks of Tyburn, the place of execution, as being "two miles from London." From Oxford Street round to Piccadilly there was a road, called the Way from Reading, proceeding through Hedge Lane and the Haymarket—which avenues were entirely destitute of houses—to St. James's Hospital, afterwards the Palace; and a few small buildings on the site of Carlton House were all that existed of the present Pall Mall. Leicester Square was open fields; St. Martin's Lane had only a few buildings above the church toward the Convent Garden, which extended to Drury Lane.

A COMPREHENSIVE SURVEY

The Strand was a street with houses; those on the South side had gardens right down to the river, and were the property of nobles, as mentioned in another chapter; the present Treasury occupies the site of the Cockpit and Tilt Yard; opposite to it stood the Palace of Whitehall, which since the days of Henry VIII. was occupying the former residence of the Archbishop of York. From King Street, which has this year disappeared, to the Abbey the buildings were close and connected, as also from Whitehall to Palace Yard. The noblemen who lived in the Strand used to proceed to the Court at Whitehall in their own barges from their River 'stairs,' and retained a number of watermen, whom their livery protected from impressment. On the Surrey side there were but six or seven houses between Lambeth Palace and the shore opposite Whitefriars. There a line of houses with gardens began which was continued to the Bishop of Winchester's Palace, where now is Barclay and Perkins's Brewery. Opposite Queenhithe was a great circular building for bull and bear-baiting. It was largely patronised, by Queen Elizabeth among others. Southwark extended but a little way down High Street. London Bridge was crowded with buildings. Along Tooley Street to Horsley Down there were many buildings.

Such was London towards the end of what we have defined as the Mediæval period. But it was, thanks to the enterprise of the time, on the rapid move. The citizens were able to send sixteen ships fully equipped, and armed with 10,000 men, against the Spanish Armada. In 1594 the Thames water was first raised for the supply of the city. In 1613 Sir Hugh Myddleton completed the New River. In 1616 the paving of the streets with flagstones was first introduced. Many years, however, were to elapse before sanitary science could be called in for the public health. In 1603 the plague destroyed 30,578 lives.

CHAPTER II.

CIVIC RULE.

Guildhall—Its Porch and Crypt—Other Ancient Crypts—Royal Control—Civic Government—Punishment for Trade Offences—The City Prisons—The Mayoralty—"Ridings and Pageants"—The Marching Watch—The Common Council—Office of Sheriff—Historic Scenes at Guildhall—Guildhall Chapel and Library—The Livery Companies.

IN the very centre of the old city, and only just removed from the noise and bustle of its great thoroughfare, the Chepe, lay the Guildhall, the seat of civic government. The name itself is eloquent of mediæval feeling, when the citizens were all enrolled under their various guilds, each owing strict obedience to the master and wardens of his guild seated at their hall; and the guilds themselves, close upon one hundred in number, being in their turn under the jurisdiction of the Mayor and Aldermen, sitting in their Court at the Guildhall. These were not the times of social liberty; the oppressive rule of the great feudal lords had been exchanged for the close personal supervision of the ward, the guild, and the church.

The site of the old Guildhall corresponded with that of the present structure, but the original entrance was from Aldermanbury. An enlargement of the ancient building appears to have taken place in the year 1326, during the Mayoralty of Richard le Breton, and further extensive repairs were carried out in the years 1341–3.

The old hall, which Stow describes as "a little cottage," was replaced by "a large and great house as now it standeth," in 1411. The building occupied ten years, the funds being procured from gifts of the livery guilds, fees, fines, and money payments in discharge of offences. The porch and crypt have survived in much of their original beauty. The former consists of two vaulted bays richly groined, with

moulded principal and secondary ribs, the intersections being adorned with sculptured bosses, the two principal of which bear the arms of Edward the Confessor and Henry VI.

The porch was known as the Guildhall Gate, and there was a lower gate which was probably situated in a line with the Church of St. Lawrence Jewry, in Gresham Street.

The crypt is one of the best of the few mediæval examples remaining in London. It forms the eastern portion of the sub-structure of the hall, and is 76 feet by 45¼, with an average height of 13 feet 7 inches. It is divided into three equal portions by clustered columns of Purbeck marble, from which spring the stone-ribbed groins of the vaulting. The bosses at the intersections are all carved with devices of the usual mediæval character, and include the arms assigned to the Confessor and those of the See and City of London.

Of these crypts—a beautiful feature of ancient architecture in which London formerly abounded—the great part have disappeared. There are those of the Church of St. Bartholomew the Great, Smithfield; Bow Church, Cheapside (used for burial purposes); Etheldreda's Chapel, Ely Place; the Priory Church of St. John, Clerkenwell; Lambeth Palace; Merchant Taylors' Hall; and St. Stephen's Chapel, Westminster. Several fine examples have been destroyed within quite recent times, including the crypt or Lower Chapel of Old London Bridge, Gerard's Hall crypt in Basing Lane, and that under the Manor of the Rose in Lawrence Pountney Hill, the two latter buildings being fine examples of the houses of distinguished citizens. To this tale of destruction must be added the crypts of Lamb's Chapel in Monkwell Street, Leathersellers' Hall, St. Martin's-le-Grand, and St. Michael, Aldgate.

The Guildhall was, in a very real sense, the centre of civic government. In early times the Mayor, Aldermen, and Sheriffs were practically the King's servants, and responsible to him at their personal peril for the good and quiet government of the city. For this purpose an adequate authority was conferred upon the civic magnates over the life and liberty of each individual citizen. The city was divided into twenty-five wards, over each of which an Alderman presided, who was responsible for its good government to the Mayor. Severe was the punishment for an insult offered to one of these dignitaries. In 1388,

Richard Bole, a butcher, for insulting William Wotton, alderman of Dowgate, was, by order of the Mayor, imprisoned in Newgate, and ordered, as a penance, to carry a lighted torch, with head uncovered and bare legs and feet, from his stall in St. Nicholas' Shambles to the Chapel of the Guildhall. Rough-and-ready justice was administered by the Mayor and his brethren, the Aldermen. In 1319, William Spertyng, who was found guilty of exposing for sale at the shambles two putrid carcases, was sentenced to be put in the pillory, and to have the carcases burnt beneath him. A vintner named John Penrose, convicted in 1364 of selling bad wine, was ordered to drink a draught of the "same wine which he sold to the people," the remainder to be poured on his head, and he to forswear the calling of a vintner in the City of London for ever. For giving short weight, in 1377, two charcoal dealers were set in the stocks on Cornhill, whilst six of their badly filled sacks were burnt beside them. A baker, for selling bread of light weight, was dragged through the city on a hurdle with the offending loaf hung about his neck. An illustration of this punishment is given in an ancient book belonging to the city records, known as the "Liber de assisa panis." Another punishment which must have been sufficiently deterrent was that of whipping at the cart's tail for petty larceny and other minor offences.

One of the most ancient prisons of the city was the Tun, in Cornhill, the site of which is still marked by the Cornhill pump. The prison consisted of a wooden cage, with a pillory and pair of stocks attached. Below it was the conduit built by Henry Wallis, Mayor, in 1282.

The City Gates were also used for the confinement of prisoners, chiefly Ludgate and Newgate; the former was devoted to prisoners for debt, and the latter to those charged with criminal offences. The scanty accommodation afforded by these structures caused grievous suffering to the unhappy offenders, gaol-fever frequently breaking out, and raging not only amongst the prisoners themselves, but also among the judges and other officials of the neighbouring Courts of Justice.

Close by, on the east side of Farringdon Street, near Ludgate Circus of to-day, was the Fleet Prison, which, like that of Ludgate, had a grate, behind which the prisoners used to beg for relief from the passers by. Its early history can be traced back to the period of the Conquest; it formed part of the ancient possessions of the See of Canterbury, and was

held in conjunction with the Manor of Leveland, in Kent, and with the "King's Houses" at Westminster. The wardenship or sergeancy was anciently held by eminent personages, who also had custody of the King's Palace at Westminster. This, with other city prisons, was burnt down by the followers of Wat Tyler in Richard the Second's reign.

Besides the King's prisons were the Compters, or city prisons, two in number—one belonging to each of the Sheriffs. They were used for the confinement of debtors, for remands and committals for trial, and for the custody of minor offenders.

The great prosperity of the City of London brought its citizens a large measure of wealth and influence. They were thus enabled, by gifts and loans to the various English sovereigns, who had constantly to contend with financial difficulties, to secure for themselves franchises and liberties far exceeding those of any other city or town. In several of their early charters they are addressed by the King as his Barons of the City of London. These privileges, or some of them, were frequently revoked by the early kings for real or alleged offences on the part of the citizens, but were always re-granted on the payment of a sufficient fine.

William the Conqueror's charter, as we have seen, is still preserved in the Guildhall. King John granted the Londoners the right of electing their Mayor, and in the following reign they were permitted to present their newly elected Mayor for the King's approval to the Barons of the Exchequer whenever the King was absent from Westminster. Previous to the election of a new Mayor, a religious service, consisting of the Mass of the Holy Ghost, was held in the Chapel of St. Mary Magdalen, adjoining the Guildhall. The ceremony of swearing in the new Mayor on the day before his assumption of office still takes place annually at the Guildhall, and has probably but little altered during the last four centuries. Besides presiding over the Court of Aldermen and the Courts of Common Council, Common Hall, and Husting, it was the duty of the Mayor, assisted by the Recorder and Common Serjeant, to administer justice in the Mayor's Court, as well as at the Newgate Sessions. He also attended St. Paul's Cathedral in state on several occasions in the year, as well as minor religious services at the Guildhall Chapel and elsewhere. The religious processions on these occasions, and the secular pageantry which was still more frequent, were ardently looked

forward to by the citizens and their apprentices as an excuse for a holiday. Chaucer, speaking of the city apprentice of his day, says that—

> "When there any riding was in Chepe
> Out of the shoppe thider wold he lepe,
> And till that he had all the sight ysene
> And danced well, he would not come agen."

The great City Fairs were opened by the Mayor with much state, the proceedings displaying a curious mixture of religious and secular ceremonial. To open the Fair of Our Lady in Southwark, the Mayor and Sheriffs rode to St. Magnus' Church, after dinner, at two o'clock in the afternoon. They were attended by the Sword-bearer and other officials, and were met by the Aldermen in their scarlet gowns. After evening prayer, the whole of the company rode over the bridge in procession, and, after passing through the fair, returned to the Bridge House, where a banquet was provided for them. With equal solemnity, the well-known Fair of St. Bartholomew in Smithfield was opened by the civic fathers. Here a Court of Piepowder* was held for settling disputes without delay, this Court being described by Blackstone as being the most expeditious court of justice known to the law of England.

The chief pageant of the year was that prepared for the Mayor of London upon his installation into office. The origin of these "ridings," as they were termed, dates back to King John's charter of 1215, already mentioned, which stipulated that, after his election by the citizens, the new Mayor should be submitted to the King for approval.

From this originated the procession to Westminster, when the Mayor was accompanied by the Aldermen and chief citizens on horseback, with minstrels and other attendants. For nearly two centuries the procession retained much of its original simplicity. The first recorded instance of a pageant approaching the character of the spectacles of the sixteenth and seventeenth centuries occurs in the year 1415. John Wells, Grocer, was Mayor, and three *wells* running with wine were exhibited at the conduit in Cheapside, attended by three virgins to personate Mercy, Grace, and Pity, who gave of the wine to all comers. These wells were

* "*Piepoudre*, so called from the dusty feet of the suitors; or, according to Sir Edward Coke, because justice is there done as speedily as dust can fall from the foot."—*Blackstone's Comment.*, vol. iii., chap. 2.

surrounded with trees laden with oranges, almonds, lemons, dates, &c., in allusion to the Mayor's trade and Company.

The greatest of these spectacular efforts were reserved for Royal visits to the City. On the return of Edward I. from his Scottish victory in 1298, Stow tells us "every citizen, according to their severall trades, made their several shew, but specially the fishmongers, which in a solempne procession passed through the citie, having amongst other pageants and shews foure sturgeons gilt, carried on foure horses; then foure salmons of silver on foure horses, and after them sixe and fortie armed knights riding on horses, made like sluces of the sea; and then one representing St. Magnus (because it was on St. Magnus's day) with a thousand horsemen," &c. At the Coronation procession of Henry IV., in 1399, there were seven fountains in Cheapside running with red and white wine. The King was escorted by a large number of gentlemen with their servants in liveries and hoods; and the City Companies attended, clothed in their proper liveries, and bearing banners of their trade. When Henry V. arrived at Dover from France in 1415, the Mayor, Aldermen, and "craftsmen" rode to Blackheath to meet the King on his road to Eltham with his prisoners. They were attended by three hundred of the chief citizens, uniformly clad, well mounted, and wearing rich collars and chains of gold,

Another picturesque ceremony was the Marching Watch, on the Eve of St. John the Baptist and St. Peter's Eve, which developed at a later period into a costly and sumptuous pageant. Elaborate dresses were worn both by the citizens who attended in the procession and by the men who carried cressets and other lights. The Mayor's household, from small beginnings, came eventually to consist of nearly forty officers under the control of the four esquires, who were the Sword-bearer, the Common Hunt, the Common Crier, and the Water Bailiff. To these must be added the Lord Mayor's Jester or Fool; the name of one who held this office, Kit Largosse, has come down to us.

The office of Common Hunt recalls the hunting privileges of the Mayor and citizens. Under the charter of Henry I., dated 1101, the citizens received a grant and confirmation of their "chaces" to hunt "as well and fully as their ancestors had" in the forests of Middlesex and Surrey, and on the Chiltern Hills. This much-valued right has

long since been commuted by the grant of venison warrants, under which the Lord Mayor, Sheriffs, with the Recorder and other officers, still receive deer from the Royal forests to the total number of twelve bucks and twelve does annually.

The city sceptre is undoubtedly of Anglo-Saxon date, but the rest of the civic insignia—city purse, mace, and swords of state—belong to Tudor or later times. There are two city seals: one, the corporate seal, with an ancient obverse of St. Paul, bearing a sword and banner surrounded by the inscription, "Sigillum Baronum Londoniarum;" the reverse originally bore the effigy of St. Thomas à Becket, for which, in 1530, the city arms were substituted. The other seal, that of the mayoralty, was made in 1381 to replace an older seal. It bears the images of St. Peter and St. Paul with the arms of the city beneath, supported by two lions; the encircling legend is, "Sigillum Officii Majoratus Civitatis Londini."

The Court of Common Council had an origin subsequent to that of the Court of Mayor and Aldermen. In 1273, divers men whose names are recorded in the city books were elected by the whole community to consult with the Mayor and Aldermen on the affairs of the city. This method of election gave way, in 1347, to the selection of representatives from each ward. Under a precept of Edward III., in 1376, the representation of the commonalty was transferred from the men of the wards to the men of the guilds, each of the latter nominating from two to six of their number as members of the Common Council. This lasted until 1383, when the right of election was restored to the wards, and a proportionate number of representatives assigned to each. Both the Lord Mayor and Aldermen formed then, as now, constituent parts of the Court of Common Council.

The office of Sheriff of London dates back to a period before the Norman Conquest, and its origin cannot be traced. King Henry I., soon after his accession in 1100, granted to the citizens of London the revenues of the county of Middlesex to farm, on their paying an annual rent of 300*l.*, and gave them liberty also to appoint from among themselves a sheriff to receive the demesne dues. The Sheriff of Middlesex therefore represented the whole body of citizens acting in their corporate capacity, the duties of the office being performed by the two sheriffs.

jointly. The election of sheriffs took place annually at Guildhall on Midsummer Day, the liverymen of the various Companies being there assembled in Common Hall for that purpose. In civic ceremonials the sheriffs ranked below the aldermen, being, in fact, the Mayor's deputies as they are styled by John Carpenter, Common Clerk in the time of Sir Richard Whittington. Each sheriff had a Court, in which he sat as judge; and, besides other obligations to the Sovereign and the Mayor, they were responsible for the safe keeping of the prisoners in the city prisons, as well as for the carrying out of sentence on those capitally condemned. They also had their "ridings" when they attended to be sworn into office, and were accompanied by the members of their guild with drummers and minstrels.

Before leaving the subject of the Corporation, we may pause for a moment to recall some of the more striking scenes which have taken place at the Guildhall. The fine building, when at length completed at the close of the reign of Henry IV., was a beautiful and conspicuous object with its high-pitched roof and two handsome louvres. Among the principal contributors to this great work were the King himself, all the aldermen, who between them glazed the windows, and Sir Richard Whittington, who, by his executors, paved the hall with Purbeck stone. In January, 1308, Queen Isabella, the wife of Edward II., wrote from Windsor to the Mayor, Aldermen, and Commonalty of London to inform them of the birth of her son. The whole of the week following was given up to solemn thanksgivings mingled with festivities, the latter including a sumptuous repast at the Guildhall, "which was excellently well tapestried and dressed out." Another sumptuous entertainment took place in May, 1357, in honour of Edward the Black Prince and his prisoner, John, king of France. One of the last public acts of Sir Richard Whittington as Mayor was to entertain in princely fashion Henry V. and his Queen at the Guildhall. This was one of the earliest occasions of the use of the new building for such a purpose. At this banquet Whittington is reported, with what truth it is impossible now to determine, to have thrown into the fire bonds under which the King was indebted to him to the extent of some 60,000*l*.

Scenes of a sterner kind have cast their shadows over the memories which surround this ancient hall. One of the earliest trials recorded

to have taken place beneath its roof arose out of a conflict between the poulterers and fishmongers in the year 1340. The Lord Mayor and Sheriffs, while endeavouring to suppress the riot, were assaulted; two of the ringleaders, having been arrested, were brought for trial to the Guildhall. They were at once condemned to death by Andrew Aubrey, the Mayor, and were forthwith beheaded in Cheapside. The King, on being informed of the matter, commended the Mayor for the action which he had so promptly taken. Others who suffered in mediæval times, after condemnation in Guildhall, were Master Roger and Master Thomas, who were tried for treason and sorcery in 1441; Roger Bolingbroke, found guilty in the same year of conspiracy against Henry VI.; and Lord Say, who was brought from the Tower to Guildhall to be tried in July, 1450. Guildhall was the scene of a momentous decision on June 24th, 1483, when the Duke of Buckingham, who had been sent by the Protector Gloucester to win the citizens of London over to his cause, drew from them a most unwilling consent to the proclamation of his patron as King Richard III.

There were two important buildings within the precincts of Guildhall. Adjoining the Guildhall Chapel, and placed under the charge of its College of priests and chaplains, was a "fair Library" founded by Richard Whittington, through his executors, and by the executors of William Bury, in 1425. The building stood by itself, and was substantially built with an upper and lower floor. It was known as the "common library at Guildhall," and John Carpenter, Common Clerk, one of Whittington's executors, left a selection of his books at the discretion of his executors, to be chained in the Library for the use of its visitors and students. The story of the despoiling of this noble institution belongs to a later period, when the Protector Somerset, not content with destroying churches and mansions to build himself a Palace in the Strand, in the year 1550 borrowed all the books from Whittington's Library at Guildhall and never returned them. Blackwell Hall, another famous building, adjoined Guildhall Chapel to the south, facing Guildhall Yard. The building was originally the property of the Basings and the Cliffords, and passed subsequently to the Banquelles or Blackwells, whence its name was derived. Reverting afterwards into the hands of the Crown, it was sold in 1398 by Richard II. to the Mayor and Corporation for

50*l*., and was then thrown open as a market-place for the sale of all descriptions of woollen cloth. The appointment of keeper of Blackwell Hall was in later times vested in the Drapers' Company.

The origin of the Livery Companies is wrapped in impenetrable obscurity. The attempt to trace them back to Roman times, though put forth by some writers of authority, is entirely wanting in evidence for its support; and the want of continuity in the early history of this country between Roman and later times forbids the acceptance of such a theory. Other writers have found the origin of the Guilds in the Gilda Mercatoria or Guild Merchant, but this view is equally without evidence, as in London no traces of the existence of a Guild Merchant are to be found. The derivation of the term "Guild" is from the Anglo-Saxon verb "gildan," to pay, and the primary obligation of each member of a guild was to contribute his fixed annual payment to the common fund of the brotherhood; his other duties included attendance at the business and religious meetings of the guild, and at the funerals of deceased brethren. Two, at least, of the Guilds—the Saddlers and the Weavers—clearly date back to the Anglo-Saxon period. At the west end of Chepe, and on its north side, was a locality known as the Saddlery of West Chepe. In its midst, adjoining Foster Lane, was Saddlers' Hall, and close by, to the west, were the precincts of the ancient monastery of St. Martin-le-Grand. The two institutions were on friendly terms, as is shown by a document in the Chapter House, Westminster, undated, but ascribed to the latter half of the twelfth century, which records the terms of a convention between the Guild and the church, the substance of which is as follows:—In return for the prayers of the Brethren of St. Martin for the souls of the members of the Fraternity of Saddlers, both living and deceased, the Saddlers covenant to make their offerings at St. Martin's shrine, and to pay all other lawful demands. This deed, within one hundred years of the Conquest, makes mention of *ancient* statutes then existing between the two bodies; there is consequently little doubt that the origin of the Guild of Saddlers belongs to Anglo-Saxon times. The Guild of Weavers is at least of equal antiquity. This powerful body paid the sum of 16*l*. into the King's Exchequer in the year 1130 by the hand of Robert, son of Lefstan, who was probably Alderman of their Guild,

the head of a guild being known by the title of Alderman in the earliest times.

It is not easy to decide whether the guilds were at first bodies of London artificers who were subsequently associated for religious and social purposes, or whether they had their origin on the social and religious side, their connection with a particular trade being of subsequent date. In either case the association between the guild and the craft must, from the conditions of London society in the Middle Ages, have inevitably arisen. The different trades were located in separate districts of the city. Besides the Saddlers, there were the Goldsmiths of West Chepe, the Mercers further east, the Poultry adjoining, the Pepperers of Soper Lane; Cordwainer Street, where the shoemakers lived; Threadneedle Street, the home of the tailors; Stocks Market for the fishmongers, the Shambles for the butchers, Bread Street for the bakers, the Vintry for the wine-sellers or vintners, and so on.

It seems most probable that in the first instance the association between guild and craft was a local one, namely that of neighbours who met together for purposes of good-fellowship and for association in religious duties. This view is strengthened by the fact that all the older guilds have a patron saint, on whose day their annual elections were held with full civic and religious formalities, which survive in many of their details to the present day. Thus, the Fraternities of the Mercers, Drapers, Pewterers, and other Guilds were dedicated to the Virgin Mary. The Haberdashers possess a patron saint in St. Catherine; the Goldsmiths in St. Dunstan, the famous artificer in metals and courageous Bishop of London in Saxon times. The Vintners claim St. Martin for their patron, and St. Cecilia is the patroness of the Musicians' Company. St. Anthony is the patron of the Grocers' Company, St. Clement presides over the destinies of the Founders, and the Barber-Surgeons are under the protection of two saints, viz., St. Cosmo and St. Damian.

Henry II. amerced several of the guilds as "adulterine," that is, set up, without the King's licence, among them being the Goldsmiths, Pepperers, and Butchers. Henry III. granted charters to the Cappers and Parish Clerks, and confirmed that of the Burrillers or Cloth Dressers; and Edward I., his successor, incorporated the Fishmongers, and the

Linen Armourers or Merchant Taylors. In the following reign was laid the foundation of the municipal functions and privileges of the guilds. Edward II., in his charter to the Mayor and citizens, ordered that no person should be admitted to the Freedom of the City unless he were a member of one of the trades or mysteries.

Up to this period, the control of the various crafts and trades carried on within the City had been directly in the hands of the Court of Mayor and Aldermen, who summoned to their aid when necessary the leading men of any particular trade, with whose concerns they were occupied for the time being. Owing to the growing importance of the guilds and their recognition by Royal incorporation, the City fathers gladly delegated to them the settlement of minor trade matters and disputes, and permitted them to draw up draft Ordinances for the regulation of their trade. These Ordinances were then submitted to the legal officers of the city, and if found not to conflict with the privileges of other crafts, the rights of the City itself, and those of the citizens in general, they were duly sanctioned by the Court of Aldermen.

The transformation of the Guilds or Fraternities into Crafts or Mysteries was rapidly effected in the reign of Edward III. That monarch, recognising that these societies had a powerful influence in extending the trade of the kingdom, showed them especial favour. To many he granted Charters of Incorporation, under which the head of the Company was styled the Master or Warden, instead of the old title of Alderman; the privileges which they had previously exercised by prescription being now confirmed by letters patent. The King himself became a member of the Linen Armourers' Company, and his example was followed by his successor, Richard II., and by large numbers of the nobility, both of the clergy and laity. Among the other Companies so honoured were the Mercers and Skinners, and, at a later date, the Grocers and Fishmongers.

During this reign also a new grade or rank was established among the members of each craft, namely that of Liverymen. They were distinguished from the ordinary members or freemen by a distinctive dress or livery, and by higher privileges, the chief of which was that the selection of members of the governing body, or Court of Assistants, was made solely from the liverymen. An interesting example of the

"clothing" or livery in the fifteenth century is depicted on the charter granted by Henry VI., in 1444, to the Leathersellers' Company. The dress is parti-coloured of red and blue divided into equal halves after the peculiar fashion of the period. It is furred at the bottom, at the sleeves and round the collar, and closed at the waist by a light-coloured girdle. The figures have the hair closely cropped, and wear scarlet pantaloons peaked at the toes.

An important Act passed in 1364 obliged all artificers and people of mysteries to choose each his own mystery, and, having so chosen it, to use no other. At the close of Edward the Third's reign, in 1376, a further ordinance was made, as we have seen, by the City Commonalty, transferring the right to elect all City dignitaries and officers, including members of Parliament, from the ward representatives to the members of the Trade Guilds. The right of electing members of the Common Council was soon restored to the inhabitants of the wards, but the election of the Lord Mayor, Sheriffs, Chamberlain, and other officers has continued in the hands of the livery down to the present day, a privilege unique in the history of the country.

From an early period certain of the chief Companies have been separated from the remaining Guilds, and known as the Twelve Great Companies, the rest of the Companies following after them in an acknowledged precedence. The Twelve Companies were distinguished by their greater wealth, and the Lord Mayor was obliged as a necessary qualification for office to be a member of one of these Guilds.

The inner life of these ancient Guilds, which were in high prosperity during the fourteenth and fifteenth centuries, abounds in features of quaint and picturesque interest. The chief event of annual importance in the life of the Guild was the Election Day, with its religious services, feasts, and ceremonies. A solemn dirge or requiem was held on the Eve of the Festival for the repose of the souls of the deceased brethren and sisters of the Fraternity. The procession was lighted by numerous wax torches, garnished with "points" (*i.e.*, bows) and streamers of ribbon. A frugal repast followed, consisting of a kilderkin of ale, white buns, cheese, and spiced bread. The important proceedings of the following day, that of the festival itself, began with a solemn performance of grand mass at one of the great monastic churches or at one of the

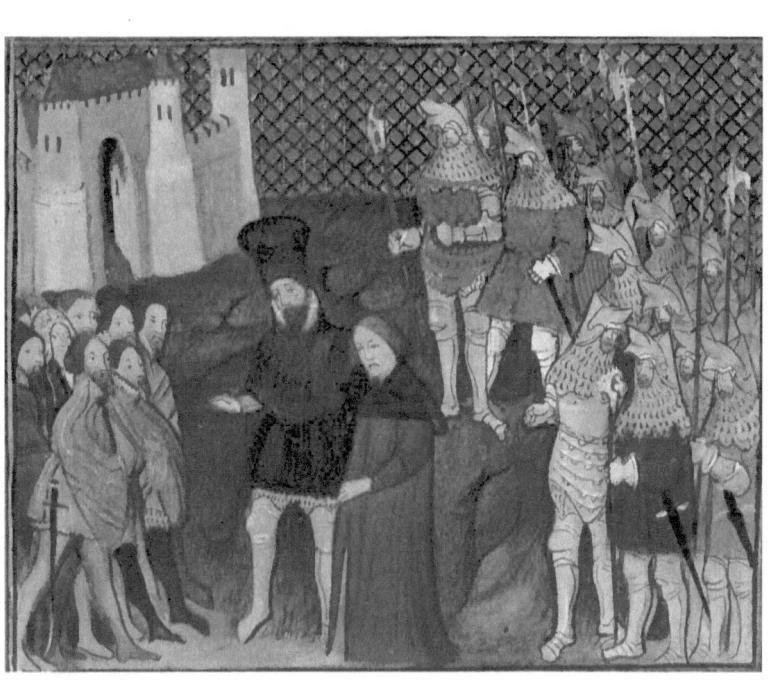

larger parish churches, the musical part of the service being rendered by the Company of Parish Clerks. The brethren attended in their new liveries, and the invited guests included Priors, Abbots, noblemen, and the Mayor and Corporation, with the chief City officials. From the church they returned in the same state to the Hall to dinner, but first the chief business of the day, the election of the new Master and Wardens proceeded with all due formality. The retiring Master and Wardens entered with garlands on their heads, preceded by the beadle and by minstrels playing. Then the garlands were taken off, and after a little show of trying whose heads among the assistants the said garlands best fitted, it was found by a remarkable coincidence that the persons previously chosen were the right wearers. The oath of office was then administered; a loving cup was next brought in, from which the old Master and Wardens drink to the new Master and Wardens, who, being now fully installed in their offices, were duly acknowledged by the fraternity.

We have been talking of Royal processions and their spectacular beauty. Our illumination gives us one scene of a tragic character. On the 1st of September, 1399, Bolingbroke, duke of Lancaster, conveyed Richard II. as a prisoner to London. He was taken to Westminster, and next day to the Tower. On the 30th, in Westminster Hall (which he had rebuilt), the unhappy King was declared deposed, amid uproarious shouts of joy, and Bolingbroke immediately rose and claimed the vacant throne. His claim was acknowledged, and the two Archbishops placed him in the royal seat. The French inscription tells how "the commons and the mob" of London led away their King to Westminster, while the Duke turned and entered by the "maistre porte" of London—"washing his hands of him," adds the old chronicler, "like Pilate."

CHAPTER III.

THE THAMES.

The "Silent Highway"—London Bridge—The Bridge Houses and their Signs—Waterworks—Ice Fairs—Swan-upping—Borough of Southwark—City Jurisdiction—Early Lords of Southwark—Winchester House—Our Lady Fair—Paris Garden Manor—Bull and Bear Baiting—Famous Inns—The Marshalsea and King's Bench Prisons—Tooley Street—Bridge House and the Bridge Masters—Sports on the Thames—Water Pageantry.

THE facilities of transit afforded by the river highway led to the extension of the City towards the East, where the necessities of commerce converted its banks into a continuous succession of quays and wharves; whilst on the West the social life of the Court and City filled the entire frontage of the waterway between London and Westminster with the palaces of the great. Here, on "the Silent Highway," all classes met. Kings and queens in the royal pomp of their state-barges were rowed from the Tower to the Palace of Westminster; nobles passed East or West from their river mansions in their journeys to the City and the Court; the merchant brought his goods to Queenhithe and the wharves; fish and other provisions were landed at Billingsgate; watermen carried passengers to Greenwich, or up stream to Hampton Court; and the City apprentices practised water-quintain and other sports, in preparation for the grand Easter aquatic tournament described by the old chronicler of Henry the Second's time, Fitz-Stephen.

The great obstacle to the navigation of the river was the picturesque but obstructive Old London Bridge. Its numerous narrow arches, whose piers rested on huge sterlings, caused so great a fall in the stream that the passage through was a feat which none but experienced boatmen could safely attempt. John Mowbray, the second Duke of Norfolk, a companion of Henry V. in his French wars, nearly perished

here in 1428. Taking barge with his retinue at St. Mary Overy, he prepared to pass through the bridge; but, through unskilful steering, the barge struck against the piles, and was overturned. Several of the party perished, but the Duke and two or three other gentlemen saved themselves by leaping on to the piles, and were drawn up with ropes to the bridge above.

The great fall of the rushing tide through the narrow arches is well shown in the earliest known view of the bridge, which is given in the beautiful illumination of the manuscript poems of Charles, duke of Orleans, who was a prisoner in the Tower of London. The date of this interesting pictorial record has been assigned to the year 1500.

The bridge consisted of a drawbridge and nineteen broad-pointed arches, with massive piers varying in breadth from twenty-five to thirty-four feet. Outside the piers were immense wooden sterlings, which were probably added later to keep the foundations of the piers from being undermined. By these obstructions the entire channel of the river was reduced from its normal breadth of 900 feet to a total waterway of 194 feet, or less than one-fourth of the whole.

Peter of Colechurch was the architect and builder of London Bridge, replacing the older wooden bridge by a stone structure which was finished in 1176. The weakness of the new building, however, soon showed itself. In 1280, less than eighty years after its completion, the bridge was so decayed that men were afraid to pass over it, and a subsidy was granted towards its restoration. A hundred years later its condition engaged the attention of "a great collection or gathering of all archbishops, bishops, and other persons." Notwithstanding the counsels of this distinguished assembly, things went from bad to worse; and in a professional survey made in 1425, one of the arches was found to be cracked, and the water-course of the Thames was seen below. This was the reason of an Act made by the Court of Aldermen, that no person should drive a cart or car shod with iron over the bridge, upon pain of "punishment of his body and to pay 6s. 8d." In 1492, a reward of five shillings was given to John Johnson, that the King's "great gonne should not pass over the bridge, but rather by another way." "The other way" involved at this date a journey up river to Kingston, where the first bridge was to be found.

For the greater part of its length, houses were built completely over the bridge, leaving only three vacancies, one an open space called the Square, not far from the city, and another at the Southwark end where the drawbridge was. The thoroughfare passed through the centre of the bridge beneath the houses, forming a kind of tunnel with shops on either side. As there was no footway, it was the safest and most usual custom to follow a carriage which might be passing across.

The practice of erecting houses on bridges frequently prevailed in early times, the object doubtless being to secure property for the maintenance of the bridge. In many instances, too, a chapel was added. A curious instance of this custom was on the bridge at Droitwich, where the road passed through the chapel, and separated the congregation from the reading-desk and pulpit. Another famous bridge chapel was erected over the river Calder at Wakefield.

London Bridge had a beautiful chapel dedicated to St. Thomas of Acon, and consisting of two floors, the upper being on a level with the Bridge road, and the lower only slightly above the level of the river, its apartment occupying the interior of the chapel pier. Another notable building was the Bridge Gate or Tower, situated at a distance of about one-third of the length from the Southwark end, and forming the boundary limit between the City and that borough. Adjoining it on the Surrey side was the drawbridge, which could be lowered for the passage of vessels up the river, and for defence of the City from the south in times of invasion. Another tower stood almost at the entrance into Southwark, on the second pier. Here, in 1263, Simon de Montfort forced a passage into the city. In 1471 the Kentish Mariners, under the bastard Falconbridge, burnt the gate, and some fourteen houses on the bridge. Sir Thomas Wyatt, in 1554, was repulsed, after a determined attack on the bridge and its defenders; not, however, before he had attacked the Bishop of Winchester's palace at the bridge foot, and cut to pieces all his books, "so that men might have gone up to their knees in the leaves so torn out." Over this tower the traitors' heads were fixed in the sixteenth century, having been removed from the Gate Tower, north of the drawbridge. These gates were decorated with leafy boughs and garlands of flowers on Midsummer Day. On the west wall,

set up in 1492, was a statue of the patron and supposed guardian of the bridge and City, St. Thomas of Canterbury.

From a period which may perhaps be assigned to the earlier part of the thirteenth century, enterprising City tradesmen had availed themselves of the excellent business situation of the bridge thoroughfare. A grant of the above-named period exists, made to the fraternity and proctors of the bridge, of "one shop upon the bridge, between the shop of Andrew le Ferun and the shop of the bridge." The shops with their various quaint signs tempted the wayfarer with a great variety of enticing wares. The Bridge Records of the fourteenth century refer to the trades of Cutter, Pouchmaker, Glover, Goldsmith, and Bowyer. At a later date we meet with the sign of the "Three Shepherds," "The Botell," "Floure-de-Lice," "Horshede," "Ravynshede," "Bell," "Bore," "Cheker," "Castell," "Bulle," "Whyte Horse," "Panyer," "Tonne," the "Nonnes," "Holy Lambe," the "Chales" (chalice), "Catte," "Bore's Head," "Seint Savyoures," "Redde Rose," "Three Cornysshe Chowys" (choughs), and many others.

The great rush of water, through the narrow arches of the old bridge, which proved so dangerous to the navigation of the river, was turned to useful account by the citizens as a motive power for water supply. Early attempts were made in this direction in 1479-80, but the project did not take practical form till 1582, when waterworks were erected under the arches nearest to the City bank of the river, on a plan devised by an ingenious Dutchman named Peter Morris.

London Bridge was the scene of a grand pageant of chivalry in 1390, when two doughty champions representing England and Scotland, engaged in a passage of arms or jousting in the presence of King Richard II. and his courtiers. The Scottish champion was Sir David Lindsay, who was opposed on behalf of England by Sir John Welles. The Scotsman was victorious, and it is characteristic of the condition of society at that period, that a safe-conduct was provided for Sir David Lindsay, both for his journey to London and return to Scotland.

Old London Bridge, after existing considerably over 600 years, was finally demolished in 1832, when the bones of its builder, Peter of Colechurch, were found beneath the masonry in the foundation of the chapel. Before its removal, the obstruction of its numerous arches and their

ponderous sterlings frequently caused the river to become ice-bound in winter. In times of more than usual severity, the frost lasted for several weeks, and fairs with amusements of all kinds were held upon the ice. The earliest of these frosts on record is that in the year 1092, and they continued at frequent intervals till so recent a period as 1814. Work being largely brought to a stop at these times, all the Londoners disported themselves on the ice, and several prints of the scenes, and chap-books and broadsides printed upon the ice, have come down to us, but are very scarce.

The swans which are met with in the upper reaches of the Thames, belong to the Crown and two of the City Companies, namely the Vintners and the Dyers. These Companies have by immemorial usage kept a "game of swans," as it is called, on the Thames, a right which is strictly confined to the Crown and those to whom the Crown may grant the privilege. Once a year an expedition was made by the swan-herds of the Companies to mark the young birds with each Company's distinguishing nicks; this was made the occasion of a festive gathering of the members of the Company, and was known as "Swan-upping." The importance which attached to this privilege in former days is seen in the nomenclature of the district in Lower Thames Street, closely adjoining London Bridge, where Old Swan Pier, Swan Lane, &c., remain to this day. At one time the Bridge House appears to have possessed the privilege of keeping a "game of swans," but this has long since lapsed, probably through non-usage.

From very early times down to the middle of the eighteenth century, the London Bridge of Peter of Colechurch, and its little-known predecessors, formed the only thoroughfare across the Thames within the limits of the Metropolis. Quite naturally therefore, the Borough of Southwark, situated at the southern approach to the bridge, early became a place of importance. For many centuries it consisted almost solely of the main thoroughfare leading to the foot of the bridge. This well-frequented route was under strict order and government, whilst the localities behind the highway on either side, and skirting the river's banks, were the resort and hiding-place of lawless persons and offenders of every description. To provide for the large number of travellers passing to

and from London and the southern counties, Southwark's main street was occupied almost exclusively by inn-keepers.

Early in the fourteenth century the citizens of London petitioned the King for jurisdiction over Southwark, which was a harbour for felons, thieves, and other malefactors. They succeeded in 1327 in obtaining from Edward III. a charter by which the King sold the vill or town of Southwark to the citizens of London, retaining for himself the Lordship of the Manor and the appointment of the bailiff. Some few years later the inhabitants regained their former privileges, and kept possession of them till the reign of Edward VI., when the Crown in 1550, by another charter, made a second grant of Southwark to the City of London for a valuable consideration.

Within a month of the grant of this charter, namely on 12th May, 1550, the Court of Aldermen appointed Sir John Ayloffe, Barber-Surgeon, as Alderman of the ward of Bridge Without, by which term the Borough of Southwark was designated for City municipal purposes.

An Act of Common Council was also passed in the following July, providing for the election of an alderman by the inhabitants of the borough. This ordinance was never acted upon, the appointment of Alderman of Bridge Without remaining in the hands of the Court of Aldermen. The constitution of the ward was never completed, no representatives were elected as Common Councilmen, and the office of alderman for this ward consequently became a sinecure. It has long been held by the senior member of the Court of Aldermen, or the next in seniority who is willing to accept it; when a vacancy occurs it is offered to the senior alderman, and on his refusal to the next in seniority, and so on. The alderman who accepts it is called the Father of the City, and thereupon vacates the aldermanship of his own ward, for which a vacancy is duly declared. The curious spectacle is thus seen of a ward presided over by an alderman, but being without a constituency or any local representation.

The Corporation of London, having been Lord of the Manor of Southwark, exercised their rights through the Recorder of London, whom they appointed High Steward of Southwark. In that capacity he held Courts Leet as Steward of the Corporation, charging the leet juries and appointing days for receiving their reports as to nuisances. This

slight jurisdiction of the City over the ancient borough has now disappeared, consequent upon the constitution of Southwark into a municipality by itself.

Now, having spoken of the City's jurisdiction, which, as we have seen, was of a very light description, we must revert shortly to the earlier history of the borough. The year 1347 found the larger part of Southwark still in the possession of the powerful family of the Earls De Warren, whose ancestor, William de Warren, was a great favourite of the Conqueror. This young lord married William's daughter or stepdaughter, and received as her dowry some 300 manors. Early in the reign of Edward III. the Earl's Bailiff and the King's had a common box for the toll collected. The King's Bailiff had the box, and the Earl's Bailiff the keys. At each division of the toll the King received two-thirds and the Earl one-third of the amount collected. In course of time the manors became vested in a larger number of owners. This appears from the names of the manors, of which the principal were the "Gildable Manor," or the Liberty of the Mayor, the Manor of the Maze, the Liberty of my Lord of Barmesey (the Abbot of Bermondsey), the Liberty of the Archbishop of Canterbury, the Liberty of Paris Garden, and the Suffolk Manor, which comprised the property of Brandon, duke of Suffolk.

Winchester House, situated west of St. Mary Overy's Church, was built in 1107 by Bishop Giffard. It has had famous occupants besides the prelates: such were Simon de Montfort and his wife; and James Stuart, king of Scotland, who was married here to the niece of Cardinal Beaufort in 1424. No less interesting was its history in later times, with which we have here, however, no concern.

From the Bridge foot, looking south, extends the great highway called Long Southwark. In this main street was held the market of the Borough, which also occupied the Churchyard of St. Margaret, at the end of the great thoroughfare. Close by, opposite St. George's Church, were the cage, pillory, stocks, and whipping-post, for the correction of offenders sentenced at the Court of Piepowder at Our Lady Fair. Behind Winchester House was the ducking-stool for sousing scolds in the river.

Southwark Fair, or Our Lady Fair, was held at Michaelmas, under

a charter granted by Edward IV. in 1462. It occupied the main thoroughfare of the Borough, and overflowed on either side into the courts and inn-yards, invading even the bridge itself. In 1499, as we learn from the Bridge House Records, 7*s.* 8*d.* was "leveid and gaderid of divers artificers stonding and selling their wares and chefres on the said bridge in the tyme of Oure Ladye Faire in Southwerke."

The Manor of Paris Garden took its name from Robert de Paris, who held the manor in the reign of Richard II. That part of the Liberty of Paris Garden bordering on the Thames was known as Bankside, and was the site of several early theatres. Long before the legitimate drama made its appearance, bull and bear-baiting flourished at Bankside. The bull-ring was the special delight of the Southwark people, and boats by hundreds were always passing to and fro, filled with sightseers from Westminster and the city.

Many of the Southwark inns had signs referring to this sport. Such were "The Chained Bull," "The Bull and Chain," and "The Bull and Dog." At the bridge foot, Southwark, was the famed tavern of "The Bear," and the token of its proprietor was impressed with a bear passant, with a collar and chain. Of the theatres which took the place of these exhibitions, and were at first contemporaneous with them, the most famous was the Shakespearian playhouse known as the Globe. It was built in 1593 for William Burbage. A licence was granted by James I. permitting Shakespeare and others to act here in 1603. The building was of wood, hexagonal in form, and was used by Shakespeare as a summer theatre. Ben Jonson was also connected with it as a partner, playwright, or actor. The building was destroyed by fire in 1613, but was rebuilt in the following year; its site is now covered by a portion of Barclay and Perkins's brewery.

The Rose was probably the oldest theatre upon Bankside, excepting the early circuses in Paris Garden already mentioned. These were leased in James the First's reign by Edward Alleyn, the founder of Dulwich College, and Philip Henslow; the latter also held the Rose Theatre for several years. The Swan was in high repute before 1598, but after 1620 both the Rose and Swan were occasionally used by gladiators and fencers. The Hope, used both for bear-baiting and as a playhouse, was situated near the Rose. In 1614 Ben Jonson's *Bartholomew*

Fair was first acted here ; at a later date the building was used for prize-fighting ; and in 1632 again for bear-baiting. In 1648 all theatres were suppressed.

Southwark was famous for its inns. The Hostelers or Inn-holders of the City of London formed themselves into a guild at an early date, and the Company still flourishes, and has a quaint old hall in College Street, Dowgate Hill. A curious petition was presented by its members in 1473 ; it complained that "the members of the Fraternity, in being called hostellers and not inn-holders, had no title by which to distinguish themselves from their servants," and prayed that they might be recognised as the "misterie of Innholders." More than 500 years later we find that the servant still keeps the title of ostler, while the master has to be content with the roundabout expression of hotel-keeper or proprietor.

Aubrey, the antiquary, writing in 1678, says :—"Before the Reformation public inns were rare ; travellers were entertained at religious houses if occasion served." The word "inn," literally a dwelling or abiding-place, was formerly used in a wide sense. The Inns of Court still retain the name ; but the town houses or resting-places of great personages, whose business brought them to London, were often so called. Thus, there were in Southwark the inns of the Bishop of Rochester and of the Abbot of Waverley, south of Winchester House; those of the Abbot of Hyde and the Abbot of Battle, and the hostelry of the Prior of Lewes. The inn of the Cobhams was the Green Dragon in Foul Lane, and was still known in 1562 as Cobham's Inn. But it is of the hostelry proper that we have now to speak.

Space will admit of little more than an enumeration of the most notable hostelries. The Chequers Inn in Chequer Court, High Street, appears to have taken its name from the arms of the De Warrens. The Boar's Head, though not as famous as its namesake in Eastcheap, was the scene of a performance of stage-plays in 1602, by the servants of the Earls of Oxford and Worcester. The Tabard, so well known as the starting-place of Chaucer's Canterbury Pilgrims, was on the east side of the High Street. It was built probably in the fourteenth century, and continued until quite modern times to possess an apartment which was known as the Pilgrims' room. Other well-known inns were the George and the Falcon.

Among the many places of interest in the High Street were the famous prisons of the Marshalsea and the King's Bench. The former was so called " as pertaining to the Marshals of England." The Court of the Marshalsea was held by the Steward and Marshal of the King's house. Both court and prison can be traced as early as Edward the Third's reign, and they no doubt existed at a much earlier period. The King's Bench Prison, familiarly known as "The Bench," closely adjoined the Marshalsea, from which it was separated by about twenty houses. To this prison, it is said, Henry V. when Prince of Wales, was committed by Judge Gascoigne for striking him when seated on the bench. Among its prisoners have been many notable persons, especially in later times.

Tooley Street, skirting the river eastward from the bridge foot, derived its name from a corruption of St. Olave's Street. St. Olaf, the Christian King of Norway, came to the assistance of Ethelred II. against the Danes in 1008, and destroyed London Bridge, which was then in their possession. He pulled down the piles of the bridge by means of ropes attached to his ships. This friendly act, together with his reputation as a Christian sovereign, procured him the gratitude of the English nation. No less than four churches in London were dedicated to this saint—those, namely, in Tooley Street, Hart Street, Silver Street, and Old Jewry.

Closely adjoining St. Olave's Church was the Bridge House, the centre of administration for the bridge and its repairs, and an institution hardly second in importance to any in Southwark. Indeed, the Borough has no other heraldic device than the curious "mark" of the Bridge House, which it has adopted as its heraldic cognisance. The origin of the Bridge House Trust extends back probably to the period of the early wooden bridge which existed before the building of Peter of Colechurch's stone bridge in 1176. London Bridge, being regarded, and with good reason, as a work of national importance, attracted a long roll of wealthy benefactors. William Rufus and his successors (probably, too, his Norman and Saxon predecessors) made grants of tolls and taxes for its support. Other benefactors included Richard, archbishop of Canterbury (Becket's successor) in 1174; Cardinal Hugo di Petraleone, papal legate to this country in 1176; Henry Fitzailwin,

first Mayor of London; and numerous wealthy citizens and ecclesiastics who, either in their lifetime or by their wills, left valuable property to the Bridge House funds. This was administered in early times by the Bridge Masters or Wardens, two in number, who were appointed by the Mayor, Aldermen, and Commonalty of the City.

This post was one much coveted in early times, and was bestowed upon men of the highest position in the City. The Wardens' duties were honourable and doubtless profitable, but they entailed great responsibilities. They had in their ward and keeping all the goods of the bridge, whether lands, rents, tenements, or commodities, and possessed large, if not absolute, powers of dealing with the bridge property by sale or otherwise for the profit of the Trust. On the other hand, their responsibility was strictly personal, and unthrifty wardens were removed from office. This was the case in 1351, when the wardens were removed after ten years' service for showing a deficit of 21*l*. odd. The unfortunate wardens for the year 1440, Thomas Badby and Richard Lovelas, owed no less than 327*l*. 9*s*. 10*d*., the loss having arisen from many of the houses on the bridge being dilapidated and unlet. The wardens obtained the King's intercession on their behalf, and the Court of Aldermen compromised the matter by accepting 200 marks in full discharge of the debt.

The wardens kept great state at the Bridge House, which was necessarily an establishment of considerable extent. Behind the Tooley Street frontage the premises extended to the river, where was a wharf for landing stone, timber, and all other necessaries for the repair of the bridge, the houses upon it, and the large property belonging to the estate. Besides the necessary offices, the Bridge House contained state apartments for official meetings, and the sumptuous entertainments already mentioned. In fact, the Bridge House in mediæval times largely resembled and took the place of the Mansion House of modern days. The building itself must have been pleasantly situated; it possessed extensive grounds, which were laid out as a garden with ponds and a fountain. The wardens kept, as we have seen, a "game" of swans, and, moreover, a pack of hounds.

Besides its great service to the citizens of London in establishing their world-wide commerce, the Thames also largely contributed to the

health and recreation of the inhabitants of London. Fitzstephen, writing in the twelfth century, thus describes the water sports in his day : "In the Easter holidays they play at a game resembling a naval engagement. A target is firmly fixed to the trunk of a tree, which is fixed in the middle of the river, and in the prow of a boat, driven along by oars and the current, stands a young man, who is to strike the target with his lance. If, in hitting it, he break his lance and keep his position unmoved, he gains his point and attains his desire ; but, if his lance be not shivered by the blow, he is tumbled into the river, and his boat passes by, driven along by its own motion. Two boats, however, are placed there, one on each side of the target, and in them a number of young men to take up the striker when he first emerges from the stream, or when—

'A second time he rises from the wave.'

"On the bridge, and in balconies on the banks of the river, stand the spectators,

'. . . . well disposed to laugh.' " *

Other recreation was afforded by fishing, as the Thames abounded with fish of all kinds, from the noble sturgeon and the salmon to the shoals of smelts and whitebait.

The river presented a gay scene, being the great highway for all classes of society, both for purposes of locomotion and for conveyance of goods. The traffic between the court and city was naturally carried on by wherries from London Bridge or Blackfriars to Westminster. The King and Queen had their royal barges, so had the noblemen whose mansions lined the south side of the Strand, each having stairs for approach from the river. Gower gives a charming picture of his meeting his patron, King Richard II., on the river, when the King summoned him to his barge and asked him to write "some new thinge." The poet obeyed by presenting the King with his "Confessio Amantis."

From time to time, gay pageants were seen on the Thames. The Sovereign would proceed in state from the Palace at Greenwich to the Tower, or from the Tower, Baynard's Castle, or other residence, to the

* This extract from Fitzstephen is from the translation in Thoms' edition of Stow, 1842.

Palace of Westminster, and the City guilds accompanied their sheriffs or mayors on their way to Westminster to take oath of office. The accounts of the Grocers' Company for the year 1436 mention payments for the hire of barges to attend the sheriffs' show; but John Stow, the historian of London, describes the water procession as an innovation made by John Norman, mayor in 1450. He writes: "This John Norman was the first mayor that was rowed by water to Westminster to take his oath, for before that time they rode on horseback. He caused a barge to be made at his own charge, and every company had several barges, well decked and trimmed, to pass along with him; for joy whereof, the watermen made a song in his praise, beginning, 'Row thy boat, Norman.'"

Of the more important buildings which formed conspicuous ornaments of the river's banks we shall speak when describing the royal palaces.

CHAPTER IV.

RELIGIOUS LIFE.

Introduction of Christianity—Foundation of the See—The First Prelates: Mellitus, St. Erkenwald, St. Dunstan—Monastic Foundations—St. Paul's Cathedral: its Officials, Services, Shrines—Old St. Paul's Described—Paul's Cross and Spital Sermons—The Jewry—London Parish Churches—Lambeth Palace and Chapel —The Lollards' Tower.

On the summit of the hill which slopes on the south to the Thames, and more steeply on the west to the rapid stream of the Fleet, has for many centuries stood a church dedicated to the great Apostle of the Gentiles. The ancient statute-book of St. Paul's Cathedral states that Lucius, king of Greater Britain, in the year 185 was converted by the emissaries of the Pope, who founded three metropolitical sees, the first of which was London. This legendary foundation of the See of London has been associated by some writers with the Cathedral Church of St. Paul, and by others with the Church of St. Peter on Cornhill. But King Lucius has long ago been dismissed into the region of myth.

Whilst, however, it is unknown how London first received Christianity, the date can be pretty closely fixed. "There can be no doubt," says Dean Milman, "that conquered and half-civilised Britain gradually received, during the second and third centuries, the faith of Christ. St. Helena, the mother of Constantine, probably imbibed the first fervour of those Christian feelings which wrought so powerfully in the Christianity of her age, in her native Britain." The memory of St. Helena has, from a very early period, been enshrined in London in the dedication of St. Helen's, Bishopsgate, formerly the Church of the Nunnery of St. Helen, the site having apparently been originally occupied by a Roman building. The parish church in Bishopsgate was built before 1010, and close adjoining was the Priory of the Nuns of St. Helen, founded about 1212.

In the year A.D. 314, more than a century before the departure of

the Romans, Restitutus, bishop of London, appears in the list of prelates who were present at the Council of Arles; and we may take it for granted that the Christian Church was duly organized at that time. But the advent of the English was the absolute and complete destruction of it for the time being. The English were entirely heathen.

The end of the sixth century saw the memorable mission of St. Augustine and his band of Christian workers. Ethelbert, king of Kent, became his first convert. In the year 604, as we learn from Ralph de Diceto, the historian and Dean of St. Paul's, "Ethelbert, the King, built the Church of St. Paul, London;" and St. Augustine himself consecrated Mellitus as Bishop of the See. The Manor of Tillingham, one of those with which that King enriched the Church, still remains in the possession of the Dean and Chapter.

What was the form of this first Cathedral, and whether built of wood or stone, we have no evidence to show. Maitland, in his History, says that the first Cathedral was built in the Prætorian camp of the Romans, and destroyed under Diocletian. He gives no authority for this statement, but it has no inherent improbability, for there are several examples in England of churches standing within ancient camps, *e.g.*, the recently discovered church at Silchester.

Mellitus, as we have already seen, was driven away by the relapse of the East Saxon King into Paganism after Ethelbert's death. But the faith was firmly implanted, and after a while burst forth in strength. Mellitus returned to England in February, 619, not to his See of London, but to succeed Laurence as Archbishop of Canterbury. He died five years afterwards (24th April, 624), a day long observed with honour in the Church of London, as may be seen in its ancient calendar.

Another of London's early prelates deserves special mention. Fourth in succession, but towering above his predecessors, both in history and legend, stands St. Erkenwald, who was consecrated in 675. He is said to have been the son of Offa, king of East England, and, when a boy, to have heard Mellitus preach in London. Before he became bishop, he had founded two famous monasteries: one for himself, at Chertsey in Surrey; the other for his sister Ethelburga, at Barking in Essex. Erkenwald held the See from 675 to 693, and was afterwards canonised. Large crowds of pilgrims flowed to his shrine in St. Paul's.

The day of his death, April 30th, and the day of his translation, November 14th, were long observed as festival days in St. Paul's Cathedral.

At an early period the retirement of a hermit's life became familiar to Englishmen, chiefly by reports from their countrymen who had travelled abroad. One of the most famous of these religious recluses was Peter the Hermit, the Preacher of the Crusades. Another class were known as anchorites, and frequently lived in or near churches; sometimes over the porch, or in other curious recesses. In the parish books of All Hallows, London Wall, are many particulars of Simon the Anker or Anchorite, who lived on the wall in or adjoining the church, and received much from the alms of the faithful. It must be added, in justice to Simon, that he proved a liberal benefactor to the Church of All Hallows.

The greatest man in England in the earlier half of the tenth century was Dunstan, who was first a student and afterwards Abbot of Glastonbury Abbey. His popularity during and after his life is shown by the numerous churches named after him. There are two in the City; and the old church of Stepney, which Dunstan rebuilt in A.D. 952 (just now, alas! laid waste by fire), is still called by his name. Some of the great monastic houses were flourishing during the late Saxon period, but the greater part grew up in Norman times.

The ancient house of St. Martin-le-Grand was founded by Witraed about the year 700, refounded in 1056 by Edward and Ingelric, and confirmed in its privileges as a secular college by William the Conqueror. By the Conqueror's charter, St. Martin's obtained its well-known right of sanctuary, which arose through its exemption from ecclesiastical and civil jurisdiction. Of the magnificent Priory of St. Bartholomew, Smithfield, we have previously spoken. Rahere, the first prior, finished the buildings in 1123, the work having occupied twenty years. Henry I., by a charter, conferred great privileges on the priory and hospital, including the right to hold Bartholomew Fair in Smithfield. The Norman Conquest brought the establishment of many new monastic foundations, but the policy adopted in founding them was to rob the parishes of their endowments. Instances of this are everywhere to be found. Rufus gave the endowment of Chesterfield parish church to Lincoln Cathedral. Rahere transferred to the Augustinian Canons

settled in his Priory of St. Bartholomew much revenue which belonged to churches elsewhere. The Templars and the Hospitalers had each an important settlement in London. The Templars first established themselves in Holborn, at the end of Chancery Lane, in 1118, and removed to Fleet Street, or the new Temple, in 1184. The Knights of St. John of Jerusalem founded their magnificent abode in West Smithfield, interesting remains of which are preserved in the beautiful crypt lately restored and the well-known St. John's Gate.

Among the other early foundations in Fitzstephen's time were the hospital and church of St. Katharine, by the Tower, built by Matilda, queen of Stephen; St. Mary Overy's Priory, at the Southwark foot of London Bridge, founded in 1106; and the great Priory of the Holy Trinity, without Aldgate, whose prior was an Alderman of London. Among the lesser foundations were the hospitals of St. Giles and St. Mary Spital, the nunnery of Clerkenwell, and that of St. Helen, Bishopsgate. The hospital of St. Thomas of Acon was founded by Agnes, sister of St. Thomas of Canterbury, about twenty years after his martyrdom, the site being that of the house occupied by the Becket family in Cheapside. At the Dissolution the whole was granted to the Mercers, who established on the site their hall and chapel. Besides the injury done to the parishes by the monastic system, and the consequent impoverishment of the parochial clergy, another grave evil attaching to these religious foundations was their exemption from episcopal control. This was especially the case with all the Cistercian houses. The Carthusians, an order of monks founded by St. Bruno in the later part of the eleventh century, had a famous London house, still known as the Charterhouse, established in 1349 by Sir Walter de Manny. These various Orders had standing rivalry among themselves. The Regulars, who retired from the world in complete monastic seclusion, were bitterly jealous of the Seculars, who associated themselves with the Cathedral and parochial clergy and mixed with the people. Much misapprehension prevails on the subject of these religious Orders. There was no "poverty" in Monasticism, whatever the vows. The hospitality for which their friends praised them so much was often a condition of their foundation charters, under which they were obliged to entertain their founders when they travelled that way. A striking instance is seen

in the case of Bethlehem Hospital, which was founded solely for the purpose of "entertaining the Bishop of Bethlehem if ever he should visit England"—a transparent ruse for maintaining in luxury a master who did not even wear a habit.

The coming of the Friars brought to the City still more sumptuous religious houses. The Dominicans, or Black Friars, were the first to arrive in 1221, and were followed by the Franciscans, or Grey Friars, in 1224, and these communities soon spread themselves over all the land. The Carmelites, or White Friars, came to England in 1240, and were established in London between Fleet Street and the Thames in the following year. The settlement of the Crouched, Crutched, or Crossed Friars was nearly a century later. Their home was near Hart Street, leading to Tower Hill, where they were settled in 1319 by Ralph Hosier and William Sabernes. The house of the Augustine or Austin Friars was founded by Humphrey Bohun, earl of Hereford and Essex, in 1253; and the nave of the church has fortunately been preserved for use by the Dutch Protestant Church.

It is to the cathedral of a city that we should look for the main-spring of its religious life, and it will be both useful and interesting to glance at the inner life of St. Paul's, and the leading facts in its history. Although the magnificent structure of the old cathedral perished in the Great Fire, we have fortunately, through the labours of Sir William Dugdale and others, and the extensive collection of early records preserved in the cathedral library, copious material for obtaining a fairly complete picture of Old St. Paul's. In the middle of the fifteenth century the cathedral body consisted of the following officials: The Bishop, the Dean, four Archdeacons, a Treasurer, Precentor, and Chancellor. To these must be added a body of thirty greater canons, twelve lesser canons, a considerable number of chaplains, and thirty vicars.

St. Paul's is one of the nine cathedrals of the old foundation; eight belong to the new foundation, five were founded by Henry VIII., and the remaining Sees in modern times. The churches of the old foundation were churches of secular canons; those of the new foundation were monastic houses—generally Benedictine—of which, therefore, the government had to be reconstituted. The monastic houses were ruled by the Abbot, whilst in the secular churches of the old foundation the Dean presided over the Chapter.

At St. Paul's, then, the Bishop was the highest in authority, and was received with great honour and ceremony on his visits to the cathedral. In his gift were all the prebendal stalls, and his episcopal palace stood close to the cathedral at its north-west corner.

The Dean was next in office to the Bishop; he was elected from and by the body of the Chapter. In the Dean's absence, the Sub-Dean—always one of the minor canons—fulfilled his duties in choir, and exercised his authority over minor officials, but he did not occupy the Dean's stall.

Next in dignity to the Dean were the four Archdeacons of London, Essex, Middlesex, and Colchester, the Archdeacon of St. Albans being added in the reign of Henry VIII. The Treasurer had charge of all the goods of the church, such as vestments, service-books, altar furniture, &c. He was assisted by the Sacrist as his deputy, and under the Sacrist, by three vergers.

The Precentor, with the assistance of his deputy, the Succentor, directed the music of the cathedral. The Chancellor was the person from whom the schoolmasters of the Metropolis received their licence to teach; among many other duties, he composed the letters and deeds of the Chapter, and had committed to him the punishment of clerks of the lower grade.

The Canons or Prebendaries were thirty in number, and, with the Bishop at their head, constituted the Chapter. They elected both Bishop and Dean, and each had an endowment attached to his stall. The names of the manors forming these endowments still appear above the Prebendaries' stalls. One of the stalls still bears the name of Consumpta per Mare; the estate was in Walton-on-the-Naze, and the inundation which the name commemorates seems to have occurred about the time of the Conquest.

It was the duty of each Canon, whether in church or absent, to recite daily a portion of the psalter. The first words of the section to be recited by each still stand, as they stood of old, over the stall of each of the Prebendaries. As there are thirty Prebendaries, and a hundred and fifty psalms, the portion which each was bound to repeat was about five psalms. Dean Donne, who was Prebendary of Chiswick early in the seventeenth century, wrote: " Every day God receives from

us, however we be divided from one another in place, the sacrifice of praise in the whole Booke of Psalmes. And though we may be absent from this Quire, yet wheresoever dispersed, we make up a Quire in this Service of saying over all the Psalms every day."

Of these thirty Canons, a varying number residing on the spot, and taking their part in the daily offices, were called Residentiaries. Besides a constant attendance during all the canonical hours, each Residentiary was expected to show large and costly hospitality, and this practice survived in part so late as the year 1843. Some Canons preferred to live upon their own estates, others held their stalls as one of many pluralities, for they were sometimes bestowed upon bishops, dignitaries, foreigners, and even upon children. Many of them being consequently non-resident, each Canon had a substitute called his Vicar. The vicars took rank after the chaplains, who in their turn were inferior to the minor canons. These corresponded with the Vicars Choral of the present day.

The twelve Minor Canons, a body as old as the Cathedral itself, had a Royal Charter of Incorporation as a College granted them by Richard II. in 1394. They possessed estates of their own, and had a common seal. One of their number was elected by them as Custos or Warden, and two were called Cardinals, Cardinales Chori, an office not found in any other church in England. The chantry priests, a large body of men, were bound not only to say mass at the special altars to which they were attached, but also to attend in choir, and perform there such duties as were assigned to them.

Chaucer alludes to the eagerness with which some of the country clergy, to the neglect of their own benefices, fought for chantries in St. Paul's. He contrasts with them his model parish priest.

> " He sette not his benefice to hire,
> And let his sheep accombred in the mire
> And ran to London, unto S. Paules,
> To seken him a chanterie for soules,
> Or with a Brotherhede to be withhold;
> But dwelt at home, and kepte well his folde.
> So that the wolfe ne made it not miscarry.
> He was a shepherd, and no mercenary."

It is impossible to estimate the number of persons who lived within the Cathedral Close, and were connected with its establishment. Besides the minor officers such as the almoner, vergers, surveyor, scribes, bookbinder, brewer, baker, &c., there were the chaplain and household of the Bishop, the higher officials already enumerated, the choir-boys, the bedesmen and poor, and a host of others.

The baker's task was no sinecure. It is calculated that the yearly issue of bread amounted to no less than forty thousand loaves. The weight and quality of the loaves, varying according to the rank of the persons supplied, were matters of sufficient importance to be regulated by statute.

With such an ample staff, we may naturally expect that the religious life of the Cathedral exhibited a busy scene. Seven times a day the bells of the Cathedral sounded for the canonical hours. Nocturns or Matins was a service before day-break; Lauds, a service at day-break, quickly following, or even joining Matins; Prime, a late morning service at six o'clock; Tirce, at nine o'clock; Sexts, at noon; Nones, at three o'clock in the afternoon; Vespers, an evening service; and Compline, a late evening service, at bed-time. In 1263, it was ordered that Vespers and Compline should be said together.

Besides a very ample supply of vestments, sacred vessels, relics, and ornaments, old St. Paul's possessed a fine store of service-books. The greatest treasures were probably the codices or manuscripts of the Gospels. Of these no less than eleven are mentioned in the inventory of the Visitation in 1295, some written in the very large letters of the Saxon period. The ritual books included many fine examples of psalters, antiphonals, books of homilies, missals, manuals, graduals, &c., all beautifully, and even gorgeously bound. The scriptorium of the Cathedral was an important department, and was ably governed. Here were prepared, not only the service-books needed for the church, but the cathedral statutes. The Pauline scribes wrote a bold, clear hand. The inks, both red and black, retain their full lustre, as may be seen by the beautiful examples remaining at the Cathedral Library.

Vestments, plate, and, unfortunately, books also have all disappeared. The loss of the latter is irreparable. Like Sarum, York, and Hereford,

St. Paul's had a "Use" of its own, and of this Use, unfortunately, no example is extant. In 1415, Bishop Clifford, with the consent of the Dean and Chapter, decreed that the Divine Office in St. Paul's should henceforth be conformable to that of the Church of Salisbury.

The feast days were numerous. Those of the first class included two feasts of St. Erkenwald and the two feasts of St. Paul. On these days the bells were rung two and two before the peal was sounded; on ordinary days they were sounded singly. It will be seen that there was thus an unceasing round of services, extending almost through day and night.

The ordinary daily services were supplemented still further by occasional services. There were the pilgrims to the shrines of Erkenwald and Mellitus; and a short form of prayer, with a hymn, which appears to have been used on these occasions, was printed by the late Dr. Sparrow Simpson, Sub-Dean. An extraordinary instance of this devotion occurred in 1322, when Thomas, earl of Lancaster, grandson of Henry III., and cousin of Edward II., who was then king, was taken captive after his defeat at the battle of Boroughbridge. Six days afterwards he was tried, condemned, and beheaded in his own Castle of Pomfret by a court of peers, with Edward himself at their head. He was sentenced as a rebel taken in arms against the King, and his whole life-record was that of an unscrupulous, treacherous, and selfish man. Yet, owing perhaps to his kindness to the poor and bountiful patronage of the clergy, his fame grew after his death. Miracles were said to have been wrought at his tomb and at a tablet in St. Paul's, erected to commemorate him.

The people prayed for his canonisation, and thronged to the Cathedral to pay their devotion to this saint of their own making. Leaden brooches, representing a knight holding a battle-axe, have been found in London, and were probably tokens given to pilgrims who had visited the tablet. The practice of distributing signs to pilgrims visiting the shrines of saints was a very common one from early times down to the Reformation period. These pilgrim signs, or signacula, were often worn by pilgrims in their hats as a sign of distinction, and a certain flavour of holiness attached to the wearer, who had braved what in

those days were the real perils of a long and painful journey on foot to accomplish his pious purpose.

A similar practice, as is well known, prevails in the Mohammedan world, where a pilgrim to Mecca, the prophet's birthplace, receives the honourable title of Hadji. The form of the signs varied greatly, and was generally a representation of the saint or his emblem. Many were issued at the shrine of St. Thomas at Canterbury, the Canterbury Bell being a frequent device; St. James of Compostella was represented by an escallop shell, and so on. The objects, which were small, and seldom much larger than a brooch, have been found in large quantities along the banks of the Thames, where the mud appears to have had a preserving influence upon the bronze of which they are made. We can well imagine the joyous return of Chaucer's Canterbury Pilgrims, each wearing a pilgrim's sign, when their long journey was completed.

Another curious service at the Cathedral was the mock investiture of the Boy Bishop on Holy Innocents' Day or Childermas, as it was formerly called. On the Eve of St. Nicholas, the special patron of children (December 6th is his festival), the children of the choir elected one of their number to be the Boy Bishop. At St. Paul's he was arrayed in pontifical vestments with a rich pastoral staff and a white embroidered mitre. On St. John's Day, after evensong, the Boy Bishop, with his clerks, officiated at a service; occupying the upper canons' stalls, whilst these dignitaries themselves served in the boys' places as acolytes, thurifers, and lower clerks.

The next day, the Feast of the Holy Innocents, the Boy Bishop preached a sermon. Two of these sermons have been preserved, and printed by the Camden Society. The foolish and profane rites were sanctioned by so eminent a man as Dean Colet, and formed the subject of regulations drawn up so early as 1263 for the performance of this function at St. Paul's.

A brief description of old St. Paul's, the finest in many respects of our English cathedrals, must now be attempted. Crossing the unsavoury Fleet and ascending Ludgate Hill, the Londoner passed first through Ludgate a little west of St. Martin's Church, and reached the great western gate of the Close spanning the street near the ends of Creed Lane and Ave Maria Lane. The cathedral stood within a spacious

walled enclosure. The wall was built in 1109, and greatly strengthened in 1285, and extended from the north-east corner of Ave Maria Lane, running eastward along Paternoster Row to the north end of Old Change in Cheapside, thence southward to Carter Lane, and on the north of Carter Lane to Creed Lane, back to the great western gate.

Besides this principal entrance, the enclosure had five other gates or posterns. Entering at the western gate, the little church of St. Gregory is seen nestling close to the cathedral on its southern side. The church seems insignificant, and helps to show us the vastness of the cathedral, just as St. Margaret's Church brings out by contrast the magnificent proportions of Westminster Abbey.

The western front was flanked by two towers, the northern of which was closely attached to the Bishop's palace; the southern, commonly called the Lollards' Tower, was used by the Bishop as a prison for heretics. The most prominent feature was the spire, which rose from the centre of the roof to a prodigious height, 493 feet in all. The Bishop's palace was at the north-west end of the nave. Passing beyond it and its grounds, you arrived at Pardon Church Haugh. This was a goodly cloister, wherein were buried many persons of note, whose monuments surpassed those of the Cathedral itself in number and curious workmanship. The chief feature of the building was the striking series of paintings on the cloister walls, representing the Dance of Death, and beneath them a metrical description of the allegorical design, translated from the French by John Lydgate, a monk of Bury St. Edmunds, and the author of the curious poem, "London Lickpenny." Within the cloister was a chapel founded by Gilbert à Becket, the father of the famous St. Thomas. Cloister, chapel, monuments, and paintings were all swept away by the ruthless hand of the Protector Somerset to find materials for his palace in the Strand.

North of the cathedral was the college of the minor canons, and east of it Canon Alley. Between the two was Walter Sherrington's Chapel, and further east, beyond Canon Alley, was the Charnel Chapel. This old building was also pulled down by Somerset, and the bones removed from the crypt beneath taken, in a thousand cart-loads, to Finsbury Fields. The soil required to cover them raised the ground sufficiently for three windmills to stand on. The windmills are seen in Aggas' map

of London, and Windmill Street, Finsbury, now marks the site, as the name "Bunhill Fields" perpetuates the ghastly *Bone Hill*.

At the north-east angle of the choir was the famous Paul's Cross. In passing the east end of the church might be seen the magnificent Rose window, one of the very finest in all England. In the clochier or bell-tower was the bell which summoned the citizens of London to the Folk-mote held close beside it. Turning westward along the south side of the close, the traveller passed the Chapter House, with its high-pitched roof, the house of the Chancellor, and Paul's Chain, with its many fair tene-ments, and close adjoining Paul's brewhouse and Paul's bakehouse. To the west lay the Deanery, an ancient house, given to the church by the famous Dean and historian, Ralph de Diceto. At the west end, also, were the houses of the canons, vicars, and many other officials.

The interior of the cathedral was no less beautiful. The immense length of the building from east to west, through choir and nave, was very striking. Some remains of the foundation of the old building may still be seen on the south side of the present cathedral.

In the pre-Reformation services no place was found for preaching; when provision was made for the delivery of sermons, it was by the appointment of a special preacher—in later times known as lecturer—this being no part of the duty of the regular clergy. As early as 1281, Richard de Swinefield, archdeacon of London, and afterwards Bishop of Hereford, was appointed preacher of the cathedral. A few years later, Bishop Richard de Gravesend appointed a divinity lecturer, and Ralph de Baldock endowed the office in the second year of Edward II.

The two great centres of preaching were Paul's Cross and the Spital; the former was used also—and, perhaps, frequently—as a platform for exerting political influence. Here Dr. Shaw, the brother of Sir John Shaw or Shaa, Lord Mayor, harangued the multitude in support of Richard the Third's claims to succeed to the Crown, whilst the Duke of Buckingham, Richard's trusted adherent, appealed on the Protector's behalf to the chief citizens assembled at Guildhall.

The Jews had a troubled time in London, as in other parts of the country, being exposed to constant extortion by the Sovereign and his ministers. Their principal quarter was in the neighbourhood of the

present churches of St. Olave and St. Lawrence Jewry. The thoroughfare of the Old Jewry appears from Mr. Joseph Jacob's investigations to have been deserted by them prior even to their expulsion from the realm by Edward I. in the year 1291.

Besides the magnificent churches forming part of the monastic establishments, examples of which fortunately remain to us in the churches of St. Bartholomew, Smithfield, St. Saviour's, Southwark, and the Dutch Church, Austin Friars, the parish churches of the old city were numerous and important. From the inventories of their possessions prepared at the Dissolution, and preserved among the records of the Augmentation Office, it would seem that in the number of their chantries and the richness and extent of their vestments and service books, some of the larger parish churches could almost vie with the Cathedral itself. Although shorn of their magnificence by the legislation of the Reformation period, and the cruel devastation of the Great Fire, the few buildings which escaped the latter catastrophe bear evidence of their former grandeur. The most interesting of them are St. Helen's, Bishopsgate, with its fine monuments; All Hallows, Barking; St. Olave, Hart Street; and St. Giles, Cripplegate. The large number of the city churches is accounted for by the obligation of each parishioner not only to regularly attend the services at his own parish church, but to ensure the attendance also of his wife and household, apprentices and journeymen. A corresponding obligation rested upon the parish officers to provide a pew or other accommodation for each parishioner in his own parish church. In the smaller parishes situated in the heart of the city this was easy enough, but in border parishes like those of St. Botolph, Bishopsgate, and St. Giles, Cripplegate, it must always have been a difficulty to provide for the large populations which such parishes contained.

There is one very important building of which we have scarcely as yet made mention, for it lies outside London City, the residence of the Archbishop of Canterbury at Lambeth. We call it now "Lambeth Palace," but the title is of recent date—not older, indeed, than the earlier part of the nineteenth century. Up to that date its occupants dated their letters from "Lambeth House" or "Lambeth Manor." In old times the title Palcae was only given to a bishop's residence within his

own cathedral city. The Bishop of London's Palace was in St. Paul's Churchyard; his residence at Fulham was his "house."

Lambeth (= Loamhythe, *i.e.*, "muddy bank") had been in Saxon days a royal manor. Edward the Confessor's sister gave it to the See of Rochester; it came back for a short time to the Crown after the Conquest, but was restored to the Prior and Convent of Rochester by Rufus, and was transferred to Canterbury under the following circumstances.

There had been continual rivalry between the Cathedral Church of Canterbury and the Monastery of St. Augustine. The latter had asserted high rights, and had more than once claimed that of electing the Primate. More than one Archbishop, chafing at all this, determined to have a Chapter of secular canons of his own, and so be independent of the Monks. But the latter so steadfastly resisted this that it was not until 1197 that Archbishop Hubert Walter carried his point by exchanging the Manor of Darenth which he held for that of Lambeth. Darenth was nearer Rochester, and therefore more convenient for that See. Situated, as Lambeth was, immediately opposite the Royal Palace of Westminster, the Archbishop became at once the stay of the Court, and also a check upon any attempt at tyranny—a position which was strongly recognised on more than one occasion. This was really the establishment in fact, of what had been little more than theory before, the Primacy of the Archbishop of Canterbury.

Of the early buildings little is known. The oldest part now existing is the crypt, but this is not older than the early part of the thirteenth century. The present beautiful chapel was built over it by the roystering young Archbishop Boniface, uncle of King Henry the Third's wife, Eleanor. He had roused the wrath of the Londoners by forcing his way into St. Paul's Cathedral and claiming all sorts of uncanonical authority over the clergy there, winding up by beating the Prior of St. Bartholomew's unmercifully with his fists. In the result he built the Chapel of Lambeth as an amend, and it is certainly one of the most beautiful examples of Early English architecture in England. Lambeth House has undergone a vast number of changes. The great entrance gateway was built by Cardinal Morton (1486), the two northern towers by Cranmer, and the long corridor by Cardinal Pole. Later than the period with which we

are concerned, Juxon built the present library, and Archbishop Howley almost rebuilt the garden front.

The so-called Lollards' tower is a misnomer. The building bearing that name in Lollard days was at St. Paul's, though it is probable enough that some of them were confined at Lambeth. But the deeply interesting inscriptions which may be read on the Lambeth walls were mostly, if not all, cut by prisoners confined here during the Puritan wars. There is one strangely pathetic memorial, immediately opposite the door in the picture. It consists of a number of holes pricked in the wainscot beside a window looking north. Minute examination reveals that some poor creature occupied his lonely hours by pricking out a rough plan of the Great Bear and the surrounding constellations as he saw them from the window.

CHAPTER V.

THE FORTRESS, PALACES, AND MANSIONS.

Abbey of St. Peter—Westminster Palace—St. Stephen's Chapel—Geoffrey Chaucer—Westminster Hall, its Feasts and other Solemnities—Baynard's Castle and the Fitz-Walters—The City's Banner-bearer—Whitehall—Strand Mansions of the Nobility: Essex House, Arundel House, the Savoy, Durham House—Crosby Place, Bishopsgate—The Tower of London.

THE two most famous of London royal residences, the Tower of London and the Palace of Westminster, were situated respectively at the extreme west and east of the Middlesex bank of the River Thames, and there lay between them, mostly at the water-side, many another stately building honoured by royal residence.

Although there is no direct evidence, there seems every probability that the foundation of the Abbey preceded that of the Palace of Westminster. The earliest documentary evidence is a charter of Edgar, which details the boundaries of the ancient Parish of St. Margaret, the great manor with which that King endowed the Abbey. The date assigned to this document by Kemble is 971.

From Domesday Book we learn that Westminster comprised sixteen hides and a half, which apparently represent about eleven hundred acres, but this estimate is unreliable on account of the difficulty of determining exactly the modern value of a hide of land. The manor of the Abbot of Westminster in the eleventh and twelfth centuries extended eastwards almost to the River Fleet, and included a large part of the present Ward of Farringdon Without.

Edward the Confessor resided at Westminster during the greater part of his reign, and built a monastic church, on the spot where now stands Westminster Abbey. It is quite possible that he also laid the foundations of the royal palace of Westminster.

FORTRESS, PALACES, & MANSIONS

Of the Confessor's church, an interesting relic remains in the Pyx Chapel and the adjoining structures against the east cloister and the south transept. The building was cruciform, with a high central tower. The good king lived until the date of its consecration, but was too ill to attend the ceremony, for which he had made elaborate preparations. Queen Editha presided in the place of her husband, who died almost immediately afterwards, and was buried in the church.

Henry III. rebuilt the church on a grander scale, removing the older structure from time to time during the progress of the new work. This great undertaking was begun in 1246, when the east end, the tower, and the transept were pulled down, to reappear in all the lightness, beauty, and variety of the pointed style, forming a striking contrast to the massive and simple impressiveness of the Anglo-Norman edifice. Twenty-five years earlier, in 1221, Henry, then a mere boy, had laid the first stone of the Lady Chapel, and was known as its founder. His devoted interest to the Abbey Church continued throughout his reign. Funds in profusion were provided by the king, or through his instrumentality, both for the building itself and for the costly ornaments to be employed in its services.

Relics were procured to be enshrined at the Abbey, and thus attract the veneration and gifts of the faithful. Many were the donations from Henry's own royal purse, but most valuable of all was the privilege granted by the king in 1248, permitting the Abbot to hold a fair at Tothill, with privileges of an extraordinary character, all other fairs being ordered to be closed, as well as the shops of London itself, during the days of its continuance. Altogether, by various methods, a sum of nearly £30,000 was raised within the short period of fifteen years, and applied to the rebuilding of the Abbey. By the close of Henry the Third's long reign the new building had made substantial progress, and consisted of the Confessor's Chapel, the four chapels in the choir ambulatory, a large portion of the choir itself, the transepts, and probably the chapter-house. The work proceeded slowly, but steadily, for rather more than two centuries, and ended with the completion of Henry the Seventh's Chapel, the central tower never having risen upon its foundations.

The Palace of Westminster, like its sister building, the Abbey, was

remodelled by Henry III. in accordance with the architecture of his time. It was this monarch most probably who converted the apartment known as St. Edward's Chamber into the better-known Painted Chamber, by embellishing it with the masterly wall-paintings from which it took its name. In this room was signed the warrant for the execution of Charles I. Another portion of the ancient palace was the old House of Lords, so nearly destroyed by Fawkes and his fellow-conspirators. The later House of Lords also formed part of the old building, and had in the course of its history various names. First it was known, probably, as the Hall, before Rufus had erected the grand structure now known by that name, and in consequence of which erection it was designated the Little Hall. In Richard the Second's time, Little Hall had changed to Whitehall; and, again, under Henry VII., to the Court of Requests, when it was also known, according to Stow, as "the Poor Man's Court, because there he could have right without paying any money."

Attached to the ancient Palace of Westminster was the beautiful Chapel of St. Stephen, built by the Norman monarch of that name, and rebuilt by Edward I. It was destroyed by fire in 1298, and was again rebuilt during the reigns of Edward II. and Edward III., and completed in 1363 in the glorious beauty of the architecture of that period. All that now remains is the crypt or lower chapel, but the building in its original state consisted of the chapel, with vestibule, crypt, cloister, and a small oratory with chantry above. The walls were adorned with sculptures and highly artistic paintings, illustrating scenes from Scripture narratives. The endowments of the collegiate establishment, as settled by Edward III., were of a like sumptuous character. The yearly revenues amounted at the Dissolution to nearly £1100, which provided for the maintenance of a dean, twelve secular canons, twelve vicars, four clerks, and six choristers, besides minor officials.

Between the years 1389 and 1391 the office of Clerk of the Works at the Palace of Westminster was held by Geoffrey Chaucer, who also had charge of the works at the Tower and at the mews near Charing Cross. Rather more than eighty years later Westminster received the new distinction of being the home of William Caxton, the father of English printing.

Yet another building of great historic interest, happily still preserved, is the stately and venerable Westminster Hall. Built originally by William Rufus as a royal banqueting-hall, it has served this purpose at the coronations of our English sovereigns down to the reign of George IV. Here occurred one of the strangest and most picturesque events in our national history. Henry II., with the assent of a general assembly of his subjects, caused his son Henry to be crowned in his own lifetime. The feast in the great hall presented a striking scene. The old king himself waited on his son at the table as server, bringing up the boar's head with trumpets before it in the accustomed manner. His son, however, predeceased him.

Henry III. was specially distinguished for his royal hospitality. On St. Edward's Day (January 5th), 1241-2, he feasted, we are told, an innumerable multitude, among whom were the citizens of London. The latter would seem to have been somewhat unwilling guests, as they were subjected by royal edict to a penalty of one hundred shillings if they stayed away. On another occasion, the marriage of his brother, Richard, earl of Cornwall, Henry ordered thirty thousand dishes to be prepared for the banquet. A more pleasing feature of this monarch's hospitality was his generous entertainment of the poor, who crowded the Hall and its apartments year after year on the day of St. Edward, his patron saint. The great size and imposing appearance of Westminster Hall naturally led to its use for public assemblies of an extraordinary character. Here the Parliament frequently met before the division into two houses, and the Lords continued to assemble in it for some time after. Here Edward III. received his august prisoner, John, King of France, whom the Black Prince had escorted in a triumphal procession through London.

Edward's grandson and successor, Richard II., rebuilt the Hall, and covered it with its wonderful roof. The Hall, as we have said, was the scene of the unfortunate Richard's deposition, and the successful claim of his rival, Henry of Lancaster, to succeed him on the throne. In later years Westminster Hall has been the scene of a memorable series of state trials, which occupy so large a part of its traditions.

Besides the Palace of Westminster and the fortress abode of the Tower of London, there were within the City of London other places which were frequently used as royal residences. One of the most

celebrated of these was Castle Baynard, which was built by Baynard, a follower of the Conqueror. Reverting to the Crown in 1111 by forfeiture, it was granted to Robert Fitz-Richard, son of Gilbert, Earl of Clare. In 1198 the castle came by hereditary succession into the hands of Robert Fitz-Walter, who took a conspicuous part in the Barons' Wars in the time of King John. At a later time Castle Baynard was held by its lords, the Fitz-Walters, subject to a military service due to the City of London.

The Lord of Baynard's Castle was the Chatelain and Banner-bearer of the City, and as such a later Robert Fitz-Walter on 12th March, 1303, acknowledged his service for his Castle Baynard before Sir Robert Blunt, Lord Mayor of London. The City, in return, granted important rights and privileges to their great vassal, Fitz-Walter. These comprised, as we learn from Stow, a limited jurisdiction within his hereditary soke of Castle Baynard, and a high military command in time of war. The old chronicler gives a picturesque description of the formal greeting offered to their leader by the assembled citizens. The scene forms the subject of one of the modern tapestries decorating the saloon of the Mansion House.

"The said Robert ought to come, he being the twentieth man of arms on horseback, unto the great west door of St. Paul, with his banner displayed before him of his arms. And when he is come to the said door, mounted and apparelled as before is said, the Mayor with his Aldermen and Sheriffs, armed in their arms, shall come out of the said Church of St. Paul unto the said door, with a banner in his hand, all on foot; which banner shall be gules, the image of St. Paul, gold; the face, hands, feet, and sword of silver. And as soon as the said Robert shall see the Mayor, Aldermen, and Sheriffs come on foot out of the church, armed with such a banner, he shall alight from his horse and salute the Mayor, and say to him, 'Sir Mayor, I am come to do my service, which I owe the City.' And the Mayor and Aldermen shall answer, 'We give to you, as to our Banneret of Fee in this city, the banner of this city to bear and govern to the honour and profit of this city, to your power.' And the said Robert, and his heirs, shall receive the banner in his hands, and go on foot out of the gate, with the banner in his hands; and the Mayor, Aldermen, and Sheriffs shall

follow to the door, and shall bring an horse to the said Robert, worth twenty pounds, which horse shall be saddled with a saddle of the arms of the said Robert, and shall be covered with sindals of the said arms. Also they shall present to him twenty pounds sterling, and deliver it to the chamberlain of the said Robert, for his expenses that day." The Banneret then sets forth and desires the Mayor to cause a marshal, "one of the city," to be chosen for the host, and the citizens to assemble and all go under the banner of St. Paul. If they should go out of the city, then Fitz-Walter was to choose two out of every ward, the most sage persons, to look to the keeping of the city. Lastly, for every siege which the host of London should lay against town or castle, the said Robert shall have one hundred shillings and no more. Baynard's Castle passed from the hands of the Fitz-Walters and came into the possession of the celebrated "Duke Humphrey," on whose attainder it was seized by the Crown, and, as we have already said, became one of the royal places of abode within the city.

Close by Baynard's Castle to the west, and at the mouth of the river Fleet, stood the palace of Bridewell, still more famous as a royal residence, of which we have already written.

Old Whitehall, with its Tennis Yard and Cock Pit, belongs, in its royal splendour, to later times, although it existed, under another name, from an early period. It was originally built by Hubert de Burgh, the great justiciary of the reign of Henry III. From him it passed, through an intermediate grant, into the possession of Walter de Grey, archbishop of York, who purchased it in 1248. It then became, and long continued, the London house of the See of York, and was known as York House. Wolsey was its last archiepiscopal owner, and had to surrender it to his imperious master, Henry VIII., by whom, and his royal successors, it was occupied as a palace until its destruction by fire in 1698.

The mansions of the nobility which lined the south side of the Strand, with their river gates and stairs, have an interest almost equal to that of the royal mansions already mentioned. On a site extending west from Fleet Street to the present Essex Street anciently stood a building known as the Outer Temple, which, with the Inner and Middle Temples, formed the abode of the Knights Templars. This mansion

passed, during the reign of Edward III., into the hands of the Bishops of Exeter, who made it their London residence under the name of Exeter House. It afterwards became known as Paget Place and Leicester House, from the names of two subsequent owners—Sir William (afterwards Lord) Paget, and Queen Elizabeth's favourite, the Earl of Leicester. The unfortunate Earl of Essex became in turn the owner of the property, which was then known as Essex House. Here he assembled his followers on Sunday, the 8th of February, 1600-1, and marched at their head into the City, hoping to rouse the Londoners to the support of his cause. He signally failed, and with difficulty escaped by boat to Essex House. Here he was besieged by the royal forces, to whom he surrendered with his friend, the Earl of Southampton, and paid the supreme penalty a little more than a fortnight afterwards.

Another stately river mansion was Arundel House, at first known as Bath's Inn, or Hampton Place, the London seat of the See of Bath and Wells. It was next called Seymour Place, from another owner, Lord Thomas Seymour, uncle of Edward VI. On Seymour's attainder and execution, the property reverted to the Crown, and was sold, with other messuages for the moderate sum of 41*l*. 6*s*. 8*d*., to the Earl of Arundel, who gave it his own name. This nobleman was the famous collector of the Arundel marbles, and his house was the common resort of the most famous artists of his day, among them being Inigo Jones, Vandyck, and Wenceslaus Hollar. Here, too, the Royal Society found a temporary home after the destruction of Gresham College in the Great Fire. Soon after, Arundel House, said to have been one of the finest and most commodious of London's mansions, was pulled down, its site being now occupied by Arundel, Norfolk, Surrey, and Howard Streets.

Further west we come again to a building of historic fame, which took a large part in the activities of mediæval London. This was the palace of the Savoy, built in 1245 on the spot which still bears its name, now occupied by Wellington Street at the approach to Waterloo Bridge. Peter de Savoy, its founder, was the brother of Boniface, archbishop of Canterbury, and uncle to Eleanor, the queen of Henry III. On coming to England, he was created Earl of Savoy and Richmond, and

was knighted in Westminster Abbey. The house came afterwards into the possession of the Earls of Lancaster, by one of whom it was enlarged on a magnificent scale in 1325, at a cost of 52,000 marks. John of Gaunt became by marriage the owner of the Savoy, and in 1356 it was used as the prison-house of John, the captive King of France. Here he lived for four years, and hither, on failing to fulfil the conditions of the treaty which secured to him his liberty, he chivalrously returned. On the 9th of April, 1364, he died in the Savoy, and his remains were honourably conveyed to France for burial. The great Duke of Lancaster and his Palace at the Savoy were in much danger from a rising of the citizens of London under their standard-bearer, Lord Fitz-Walter, in a quarrel arising out of the citation of Wickliffe before the Bishop of London. The danger became more real in 1381, the year of Wat Tyler's insurrection. On the 12th of June the Kentish rebels had complete mastery in London, one body marching off to attack Lambeth Palace, whilst another assembled at the Savoy. Here they set fire to the building, breaking up the gold and silver plate, while, to complete the work of destruction, some barrels of gunpowder, which the rioters supposed to have been filled with treasure, were thrown into the fire, blowing up the Hall and surrounding houses. For a century and a quarter the Savoy lay waste, and when it arose from its ruins it was endowed as a hospital by King Henry VII. Much interest attaches to the latter fortunes of the Savoy and its famous Chapel, but the story lies outside our present purpose.

Many noble mansions built in later times shared the beautiful Thames frontage with the older houses, which are the proper subject of our notice. Beyond the Savoy to the east lay Worcester, Rutland, and Cecil Houses, and then we come to Durham House, one of the oldest and most interesting in this street of palaces. It stood on the site afterwards occupied in part by the Adelphi theatre, and was originally founded by Anthony de Beck, Patriarch of Jerusalem and Bishop of Durham, in the reign of Edward I. Bishop Hatfield is said by Stow to have rebuilt it. Here the challengers in the famous joustings at Westminster, in 1540, entertained at dinner not only the King and Queen, with the Court, but also the whole House of Commons and the Mayor and Aldermen of London, with their wives. In the following reign

the Royal Mint was established in Durham House. Here, too, the unfortunate Lady Jane Grey lived, under the roof of her ambitious uncle, the Duke of Northumberland, and set out in great state from its portals on her ill-fated mission to be acclaimed Queen at the Tower.

We will now again turn our steps citywards to the great highway of Bishopsgate, where, closely adjoining the church of St. Helen, still stands the venerable mansion known as Crosby Place. Sir John Crosby, the owner and reputed builder of the mansion, was an Alderman and Sheriff of London in Edward the Fourth's reign, and served the city in Parliament in 1461; he was also Mayor of the Staple of Calais. Attaching himself to the fortunes of Edward IV., he was knighted by the King on his approach to London in 1471. Four years later Crosby died, and his magnificent abode soon became a favourite royal residence. Richard, Duke of Gloucester, whilst Protector, made this his home and the centre of his plots to secure the Crown for himself. In the story as told by Shakespeare, the usurper bids the Lady Anne—

> "presently repair to Crosby House;
> Where, after I have solemnly interr'd
> At Chertsey monastery this noble King,
> And wet his grave with my repentant tears,
> I will with all expedient duty see you."

There is little doubt that we owe the preservation of the Great Hall and so much of the rest of this fine building to the notoriety which it has gained from the allusion in the above passage. In later times the Hall was used for the acccommodation of foreign ambassadors; many a mayoralty feast was held within its walls, the most famous recorded one being that given by Sir Bartholomew Read, goldsmith, in 1502, when the guests were most numerous and "of great estate," and the provision made for their entertainment was on a scale of unparalleled magnificence.

Far away below bridge on the right bank of the Thames lay another Royal Palace, that of Greenwich. The Manor of Greenwich belonged to the Crown at an early period. In 1300 Edward I. and the Prince his son made offering "at each of the holy crosses of the Virgin Mary at Greenwich." The estate passed for a time out of Royal hands, but

Humphrey, duke of Gloucester, enclosed a park of 200 acres, built a tower known as Greenwich Castle, and the more famous Palace of Placentia, which on his death in 1447 reverted to the Crown, the Palace becoming the favourite abode of the early Tudor sovereigns.

It now remains to speak of that grand national monument which, for varied interest, exceeds all its sister buildings in the ancient city—the Tower of London. Stow has well described the various uses which from time to time it has served:—" A citadel to defend or command the city; a royal palace for assemblies or treaties; a prison of State for the most dangerous offenders; the only place of coinage for all England; the armoury for warlike provision; the treasury of the ornaments and jewels of the Crown; and general conserver of the most ancient records of the King's Courts of Justice at Westminster." The Great or White Tower was built at the command of William the Conqueror by Gundulph, Bishop of Rochester, about the year 1078. Much injury was done to the new work by a storm in 1092, and the fortifications were repaired and extended by William Rufus, who, for this purpose and for the erection of Westminster Hall, cruelly oppressed his subjects with taxes. The building of the subsidiary forts and defences appears to have continued during the reigns of Henry I. and most of his successors to the time of Edward I.

The custody of the Tower was committed by the Conqueror to a Constable or Governor, whose office was at first hereditary. In or about the year 1140 it was held by Geoffrey, grandson of Geoffrey de Mandeville, who was created Earl of Essex by King Stephen. Soon afterwards he took the side of the Empress Maud, and being besieged by the citizens, sustained the attack for a long time, and in a sally took the Bishop of London prisoner at Fulham. The Tower seems to have been regarded in those days as impregnable, and Geoffrey retained his possession of it until 1143, when he was taken prisoner by stratagem, and compelled to surrender it. The possession of the Tower fortress was always regarded by the English monarchs as of the highest importance, as it enabled them to overawe the citizens, and also furnished a safe retreat for the sovereign's own person. Longchamp, bishop of Ely, was left by Richard Cœur de Lion as chief guardian of the kingdom and in charge of the Tower during the King's absence in Palestine.

John, by his influence with the citizens, prevailed on them to desert the cause of his royal brother and Longchamp, and the latter, after handing to John the keys of the Tower, escaped, disguised as a woman, to France. During the insurrection of Wat Tyler, the mob, through some unaccountable negligence or treachery on the part of the guard, got within the Tower and overran its apartments, insulting the Princess of Wales, the mother of Richard II., and dragging forth from their refuge in the chapel Simon, archbishop of Canterbury and chancellor, and Sir Robert Hales, treasurer, both of whom they immediately beheaded. The importance attached to the safe keeping of the Tower appeared in a striking manner at a much later period, when, in 1641, Charles I. roused the whole city and both Houses almost to a frenzy by appointing and persisting in maintaining Colonel Lunsford as Lieutenant of the Tower. The appointment was universally regarded as dangerous and unfit, and the King was at last compelled to recall it. It may be mentioned, as a fact not generally known, that the Lord Mayor receives every three months a list, under the sovereign's sign-manual, of the daily pass-word to the Tower.

As a palace, the Tower can boast of an almost continuous use by the English sovereigns for five hundred years, ending with the accession of Charles II. Stephen is the first King who is recorded to have held his Court within the Tower. This was in 1140, when his affairs were not in a prosperous state, and the security of the Tower offered him a great temptation. John was also a frequent resident here, and on his death Prince Lewis, the Dauphin of France, made his abode at the Tower previous to renouncing all claim to the throne of England. Henry III., during his minority, constantly kept his Court here, celebrating the religious festivals with great pomp. These were held in the chapel in the White Tower, perhaps the most perfect Norman building existing in England; a chaplain, who received a yearly salary of fifty shillings, conducting daily service. The three Edwards who succeeded Henry on the throne, seldom resided in their London fortress, but its dungeons were filled with their foreign prisoners of highest rank. Richard II. visited the Tower to prepare for his coronation procession. On the preceding day he was welcomed in great state and with brilliant pageantry by the Mayor, Aldermen, and citizens, and this city reception became from this time an established

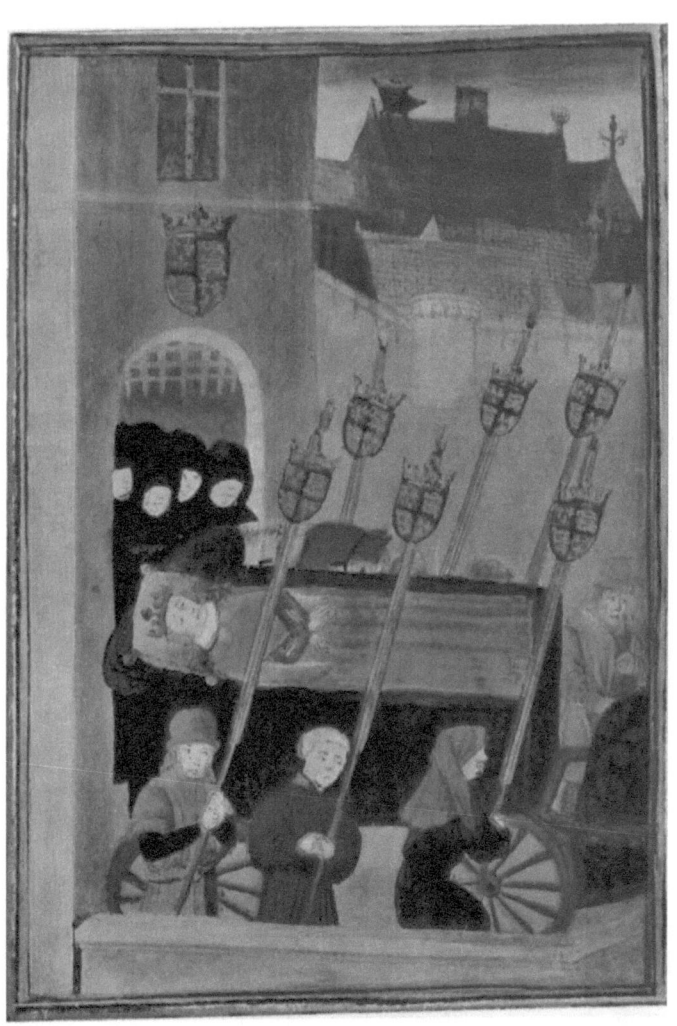

custom. Froissart gives a brilliant description of the grand tournament held in London by Richard in 1390, when the King entertained in the Tower a large number of distinguished foreign guests. It witnessed a very different scene nine years later, also chronicled by Froissart, when Richard abdicated the throne in favour of Bolingbroke. In the following year his body was brought from Pontefract to London, and carried on a bier from the Tower to Cheapside, where it lay for two hours, while 20,000 people, says Froissart, came to gaze upon his face. It was then carried to King's Langley, and interred in the church of the Dominican Friars; but was removed by Henry V. to the tomb which Richard had prepared for himself in Westminster Abbey. Neither Henry IV. nor Henry V. lived much in the Tower, but Charles, duke of Orleans, and his brother John, count of Angoulême, who were taken prisoners at Agincourt, suffered many years' imprisonment here. Among the Harleian manuscripts is a copy of the poems of the Duke, which contains the beautiful illumination, already mentioned, representing the Tower and London Bridge, with the intervening buildings, at the time of the Duke's captivity. It is reproduced in our frontispiece.

With the reign of Henry VI. begins the series of royal tragedies connected with the Tower. As king and prisoner alternately, the unfortunate monarch spent here most of his life, until after the battles of Barnet and Tewkesbury in 1471, which finally crushed his cause, he entered the Tower once more, where, a few weeks later, he was found dead, not without grave suspicion of foul play on the part of the Duke of Gloucester, the brother of his successor, Edward IV. Gloucester's brotherly regard, whether real or assumed, ceased with the King's death, and he found no words too black in which to paint the character of the late monarch, and so pave the way for his own accession to the throne. No obstacle was allowed to interfere with his ambition, and the murder of the two young princes is the saddest and most closely associated of all the historical events which give the walls of the old fortress an almost sacred character. From this cruel crime the Bloody Tower takes its name.

In the records of its later years the Tower kept up its tradition of violence and bloodshed; the little church of St. Peter ad Vincula close by bears sad witness to the dangers besetting the path which those must tread who seek for high estate.

CHAPTER VI.

THE PASSING OF MEDIÆVAL LONDON.

Changes in Human Thought in the Fifteenth and Sixteenth Centuries—Drawbacks to Civilisation, Worldliness and Neglect of Religion — Reflection of this in London Life—St. Paul's in Neglect—The Struggle for Better Things—Hope for the Future—The Great Fire.

A FEW words seem called for before we leave the middle age of the great City. The world may be said to have entered on a new life in the wonderful movements of the fifteenth and sixteenth centuries. The downfall of the ancient city of Constantinople, which had driven the scholars of the East westwards, especially into Italy, led to the great revival of learning in Western Europe. The splendid works of Architecture, and of Painting and Poetry, all trace their origin in part to this source. The discovery of the Mariner's Compass had led on to that of a New World in the West, and of the passage round Africa to the East. The new learning had produced the revolt against traditional authority in theology. All this was wonderfully influencing English, and therefore London, life. And so we have exploits of rich citizens over the seas. We have the establishment of places of education, in London pre-eminently Christ's Hospital, and the good works of Sir Thomas Gresham.

But there were unpleasing features as well. The revolt from mediævalism in religion led to very much wanton destruction in churches and religious houses. The destruction of beautiful works of religious art has often been all put down to the days of Cromwell, but this is not fair. There was a vast amount of vandalism by "hot Gospellers" in the days of Elizabeth. Thus Laud complains that he found the beautiful stained-glass windows in Lambeth Chapel all broken and "patched like a beggar's coat." One may just note here that his restorations of them were broken again in his day, and were restored by

Archbishop Tait. And even more evil was wrought apparently by neglect and worldliness; the casting off Papal authority was too often accompanied by casting off all religious restraints.

This is all seen too clearly in the records that are left to us of St. Paul's Cathedral. Grievous neglect befell it in the latter part of the sixteenth century. It is doubtful whether lightning or the carelessness of a workman set the lofty spire on fire in 1561, but it fell in and did much damage to the roof. This was to a certain extent repaired, but the glory seemed to have departed. Inigo Jones built a new west portico in Italian style, as that part had become dilapidated. Charles I. was endeavouring to restore it when the Civil Wars broke out. At the Restoration, things had, of course, become far worse, but while new plans of restoration were being discussed came the Great Fire, which for awhile settled matters. During the reigns of Elizabeth and James the Cathedral was a place of exchange and of public parade, merchants met to arrange bargains and dandies to show themselves. "The noise," said Bishop Earle, "is like that of bees; a strange humming or buzz mixed of walking tongues and feet; it is a kind of still roar or loud whisper. All inventions are emptied here, and not a few pockets. The principal inhabitants and possessors are stale knights and captains out of service." This agrees with what Falstaff tells us; he "bought Bardolf in Paul's." And Ben Jonson speaks of Captain Bobadil as "a Paul's man."

As the light of history falls on all this, it becomes clear to fair judges that whilst there was widespread ungodliness and worldliness, there were good and earnest men belonging to the two religious parties, who were striving after Reformation. The Puritan divines in the early times of the Stuarts were learned and most devout. Their commentaries on the Bible are well worth study. So are the men on the other side: Andrewes, Hooker, Jeremy Taylor, for example. The collision came, the Puritan triumph and failure, the godless reaction. The history of London during all this time again exhibits beautiful examples of men who saw opposite sides of the same good shield, and strove for the love of God to make the world better. The hand of God was visible, as J. R. Green once put it, shaping the course of the middle age, and we believe and are assured that there is still a nobler future for the City which we love, under the same Fatherly and Almighty hand.

The epitaph of the noble mediæval city which we have endeavoured to describe is engraved on the north side of the Monument on Fish Street Hill :—" In the year of Christ 1666, the second day of September, eastward from hence at the distance of two hundred and two feet (the height of this column), about midnight, a most terrible fire broke out, which, driven on by a high wind, not only wasted the adjacent parts, but also places very remote, with incredible noise and fury. It consumed eighty-nine churches, the City gates, Guildhall, many public structures, hospitals, schools, libraries, a vast number of stately edifices, thirteen thousand two hundred dwelling-houses, four hundred streets. Of the six and twenty wards it utterly destroyed fifteen, and left eight others shattered and half-burnt. The ruins of the City were four hundred and thirty-six acres, from the Tower by the Thames side to the Temple Church, and from the north-east along the City wall to Holborn Bridge. To the estates and fortunes of the citizens it was merciless, but to their lives very favourable, that it might in all things resemble the last conflagration of the world. The destruction was sudden, for in a small space of time the City was seen most flourishing, and reduced to nothing. Three days after, when this fatal fire had baffled all human counsels and endeavours in the opinion of all, it stopped as it were by a command from Heaven, and was on every side extinguished."

INDEX

Accas' Map of London, 20, 59
Aldermanbury, 22
Aldermen, 5, 23, 37, 41
Aldersgate, 10
Aldgate, 10
Alfred, King, 1, 3
Alfune, 12
Alleyn, Edward, 43
Anchorites, 51
Angevins, The, 5
Arches, Court of, 9
Arms, City, 18
Arundel House, 70
Athelstan, 17
Aubrey, 44
Augustinians, The, 13, 53
Ayloffe, Sir John, 41

Bankside, 43
Bartholomew Fair, 26, 51
Basing Hall, 8
Baynard's Castle, 10, 47, 68
Beaufort, Cardinal, 42
Beck, Anthony de, 71
Becket, Gilbert, 59
Becket, Thomas, Archbishop of Canterbury, 6, 11, 52
Bethlehem Hospital, 16, 53
Bishops of London— Mellitus, 3, 50; Maurice, 4, 11; Restitutus, 50; Erkenwald, 50; Clifford, 57
Bishopsgate, 10, 72
Black Death, The, 18
Black Friars, The, *see* Dominicans
Blackfriars, 47
Black Prince, The, 29, 67
Blackwell Hall, 30, 31
Boniface, Archbishop, 62
Borough, The, *see* Southwark
Boy Bishop, The, 58
Bread Street, 8
Bridewell, 19, 69

Bridge House, The, 43, 45
Bridge Without, Ward of, 41
Budge Row, 8
Bull-baiting, 43
Bunhill Fields, 16, 60
Burbage, William, 43
Burgh, Hubert de, 13, 69

Cade, Jack, 18
Carmelites, The, 13, 53
Carpenter, John, 29, 30
Carthusians, 13, 53
Caxton, 19, 66
Charles I., 74, 77
Charter of William I., 4
Charterhouse, The, 52
Chaucer, 26, 55, 66
Cheapside, 8
Christ's Hospital, 19, 76
Churches—All Hallows the Great, 20; All Hallows, London Wall, 51; All Hallows, Barking, 61; Austin Friars, 53, 61; St. Bartholomew the Great, 13, 23, 61; St. Bartholomew the Less, 15; St. Botolph, 61; St. Clement Danes, 7; St. Dunstan, Stepney, 51; St. George, 42; St. Giles, Cripplegate, 10, 61; St. Gregory, 7; St. Helen, Bishopsgate, 49, 61; Holy Trinity, Aldgate, 13; St. Katharine, 52; St. Lawrence, Jewry, 23, 61; St. Magnus, 26; St. Martin's-le-Grand, 11; St. Martin Pomeroy, 10; St. Mary Overy (St. Saviour's), 13, 42, 61; St. Mary-le-Bow, 8, 9, 23; St. Michael, Crooked Lane, 15, 20; St. Mildred, 8; St. Olave, Hart Street, 13, 61; St. Olave, Jewry, 61; St. Peter, Cornhill, 49; St. Peter ad Vincula, 75; St. Thomas of Acon, 38
Cistercians, The, 11, 13, 52
Civic rule, 22

Cnichten Guild, 12
Common Council, The, 19, 28, 41
Companies, The Livery—22, 27, 31–35; Barber Surgeons, 32; Butchers, 32; Cappers, 32; Cloth Dressers, 32; Drapers, 31, 32; Dyers, 40; Fishmongers, 32; Grocers, 32, 48; Goldsmiths, 32; Haberdashers, 32; Hostellers, 44; Linen Armourers (Merchant Taylors), 33; Leathersellers, 14, 34; Mercers, 14, 33, 52; Musicians, 32; Parish Clerks, 14, 32, 35; Pepperers, 32; Pewterers, 32; Saddlers, 31; Skinners, 33; Vintners, 32, 40; Weavers, 31
Corporation of London, 2, 41
Courts Leet, 41
Courtenay, Archbishop, 12
Cripplegate, 10
Crosby, Sir John, 72
Crusades, The, 12
Crutched Friars, The, 13, 53
Crypts, Ancient, 23
Curfew, The, 11

Danes, The, 3, 5, 17
Dominicans, The, 12, 53
Donne, dean of St. Paul's, 54
Dunstan, 51
Durham House, 71

East Cheap, 9
Editha, Queen, 61
Edward the Confessor, 6, 64
Edward I., 27, 61, 66, 72
Edward II., 33, 57
Edward III., 9, 33, 34, 45, 66, 67
Edward IV., 10, 19, 43
Edward VI., 10, 19, 41
Elizabeth, Queen, 19
Epidemics—The Black Death, 18; The Sweating Sickness, 19; The Plague in 1603, 21
Episcopal Residences, 15
Essex, Earl of, 70
Ethelbert, 50
Ethelred, 17
Etymology of London, 1
Exeter, Earl of, 70

Fairs, 26
Finsbury Fields, 17, 19, 59
Fire of London, The, 1, 53, 78
Fitzailwin, Henry, 17, 45
Fitzstephen, 11, 46, 52
Fitz-Walter, Robert, 68, 71

Fleet Prison, The, 24
Fleet River, The, 19, 58
Folkmote, The, 5, 8, 60
Franciscans, The, 13, 53
Friday Street, 9
Froissart, 75

Gates, The City, 10, 24
Giffard, bishop of Winchester, 13, 42
Globe Theatre, The, 43
Gower, 47
Greenwich, 47, 72
Gresham College, 70
Gresham, Sir Thomas, 76
Grey, Lady Jane, 72
Grey Friars, The, see Franciscans.
Grub Street, 16
Guildhall, The, 8, 22
Guilds, see Companies
Gundulph, bishop of Rochester, 73

Henry I., 5, 27
Henry II., 6, 32, 67
Henry III., 6, 32, 65, 67, 74
Henry IV., 18, 27, 29, 35, 75
Henry V., 27, 29, 45
Henry VI., 34, 75
Henry VII., 7, 66, 71
Henry VIII., 19, 53
Holborn, 19
Holy Trinity, Priory of the, 12, 13
Hospitalers, 52
Hospitals, 15, 19, 52
Houndsditch, 19, 20
Humphrey, duke of Gloucester, 69, 73

Ingelric, 11, 51
Inns, 43, 44
Insignia, Civic, 28
Isabella, Queen, 29

James I., 43
Jews, The, 18, 60
John, King, 25, 73
John of Gaunt, 71
Jones, Inigo, 77
Jonson, Ben, 43, 77

King's Bench, Prison of the, 45

Lambeth, 61–63, 76
Lancaster, Thomas, earl of, 57
Lindsay, Sir David, 39
Liverymen, 33
Lollards, 12, 63
London Bridge, 21, 36–40

London, Etymology of the name, 1; Growth of the City, 1-9
London Stone, 7
London Wall, 17
Longchamp, bishop of Ely, 73
Lucius, King, Myth of, 2, 49
Ludgate, 10, 58
Lydgate, John, 59

Mandeville, Geoffrey de, 73
Manny, Sir Walter, 52
Marching Watch, The, 27
Marshalsea Prison, The, 45
Mary, Queen, 1
Matilda, 5
Mayor, Office of, 23, 24; Election of, 25, 34; Duties of, 25; Household, 27; Hunting Privileges, 27
Mayors, Lord—Sir Henry Barton, 18; Richard le Breton, 22; Whittington, 14, 29, 30; Henry Wallis, 24; John Wells, 26; Andrew Aubrey, 30; Fitzailwin, 45; John Norman, 48
Mellitus, Bishop, 3, 50
Mercers' School, 15
Monasticism, 11-15, 51-53
Montfort, Simon de, 38, 42
Moor Fields, 16
Mowbray, John, duke of Norfolk, 36

Newgate, 10
Newgate Street, 7
Normans, The, 5, 17

Old Jewry, 61
Orleans, Charles, duke of, 37, 75

Pageants, 9, 26, 27, 39
Paris Garden, 42, 43
Paul's Chain, 4, 60
Paul's Cross, 8, 60
Peter of Colechurch, 17, 37, 39
Piepowder, Court of, 26, 42
Plantagenets, The, 18
Prisons, 24, 25, 47
Punishments for Trade Offences, 22, 24

Rahere, 12, 51
Religious Houses, 11-15, 51-53
Religious Life, 49-63
Richard I, 73
Richard II., 18, 30, 33, 35, 39, 47, 55, 66, 67, 74
Richard III., 30, 60, 72, 75
Roman City, The, 1, 2

St. Augustine, 50

St. Bartholomew's Priory, 12, 13, 51
St. Botolph, 3
St. Helena, 49
St. Helen's Nunnery, 14, 50
St. John of Jerusalem, Priory of, 13, 23, 52
St. Mary Overy, Priory of, 13, 52
St. Olaf, 45
St. Paul's Cathedral, 4, 7, 49, 53-60
St. Thomas's Hospital, 19
Savoy, The, 70
Sebert, King, 3, 6
Seymour, Lord Thomas, 70
Shakespeare, 43
Shaw, Dr., 60
Sheriffs, The, 23, 28
Signs, Tradesmen's, 39
Smithfield, 18
Somerset, The Protector, 30, 59
Southwark, 13, 19, 40-45
Southwark Fair, 42
Stephen, King, 5, 73, 74
Stow, John, 10, 22, 48, 66, 71, 73
Strand, The, 21, 30
Suffolk, Duke of, 42
Swans on the Thames, 40

Templars, The, 52
Temple, The, 69
Thames, The, 36, 47 64
Theatres, 43
Tooley Street, 21, 45
Tournaments, 9, 19, 39, 71, 75
Tower of London, 5, 37, 64, 73-75
Trades, 27, 32, 39
Trees, City, 10
Tyler, Wat, 18, 71, 74

Walter, Hubert, archbishop of Canterbury, 62
Walworth, Sir William, 18
Warren, William de, 42
Watling Street, 7
Welles, Sir John, 39
Westminster, 2, 7
Westminster Abbey, 6, 64
Westminster Hall, 66, 67
Westminster Palace, 65-67
White Friars, The, *see* Carmelites
Whitehall, 21, 66, 69
White Tower, The, 5, 73
Whittington, Sir Richard, 14, 29, 30
William I., 4, 6, 11
William II., 45, 51, 66, 73
Winchester House, 42
Wolsey, Cardinal, 69
Wyatt, Sir Thomas, 38
Wyclif, 12, 18.

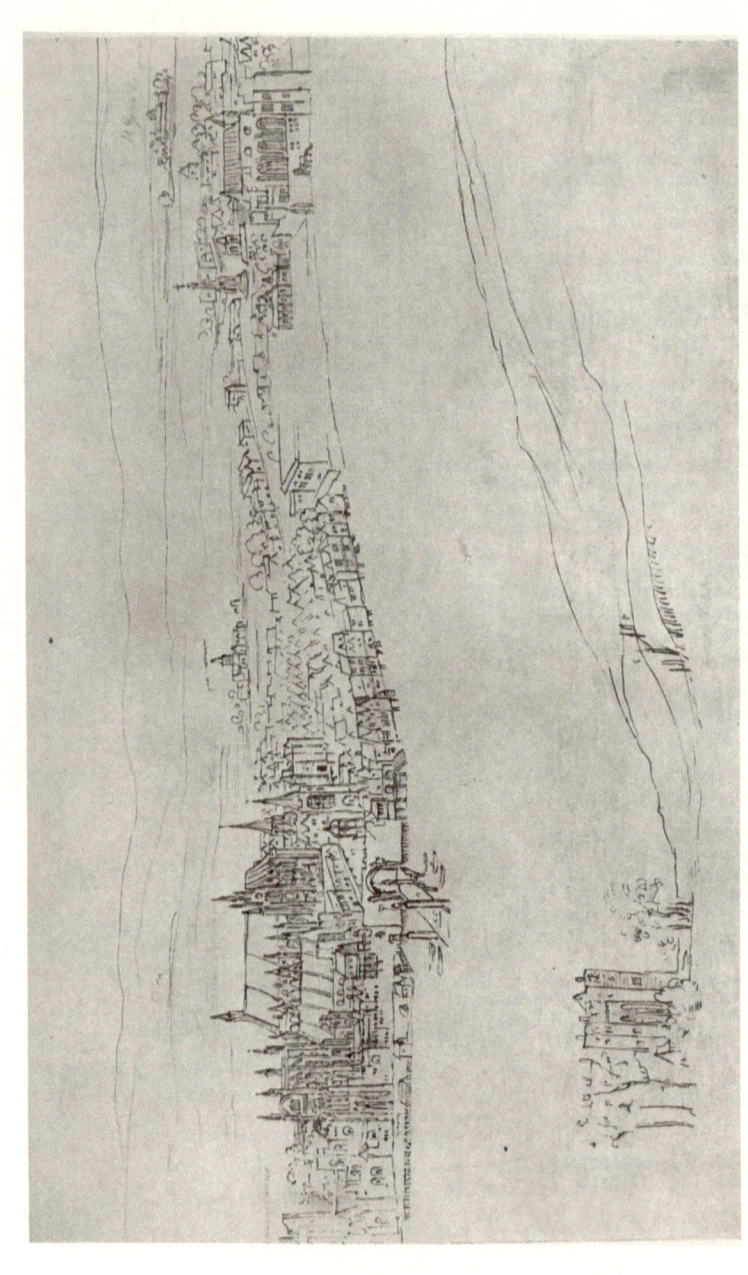

WESTMINSTER. *From the Drawing by Antonie van den Wyngaerde. Bodleian Library, Oxford.*

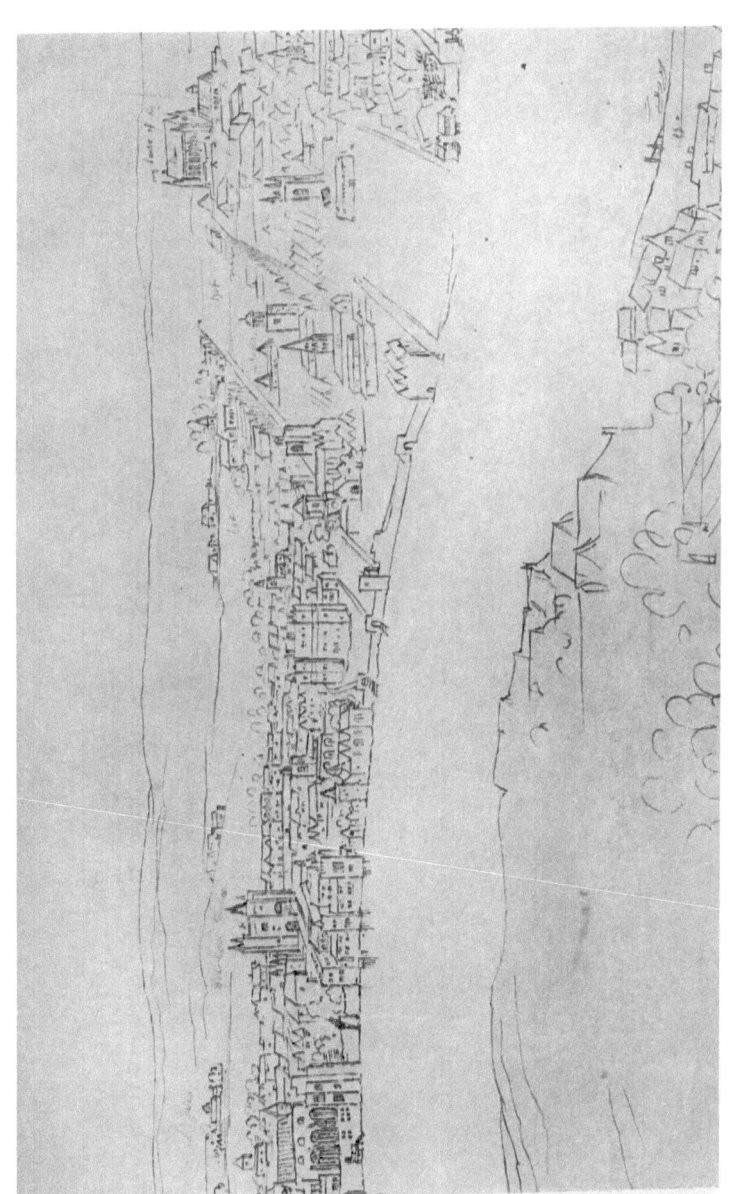

THE STRAND. *From the Drawing by Antonie van den Wyngaerde.*

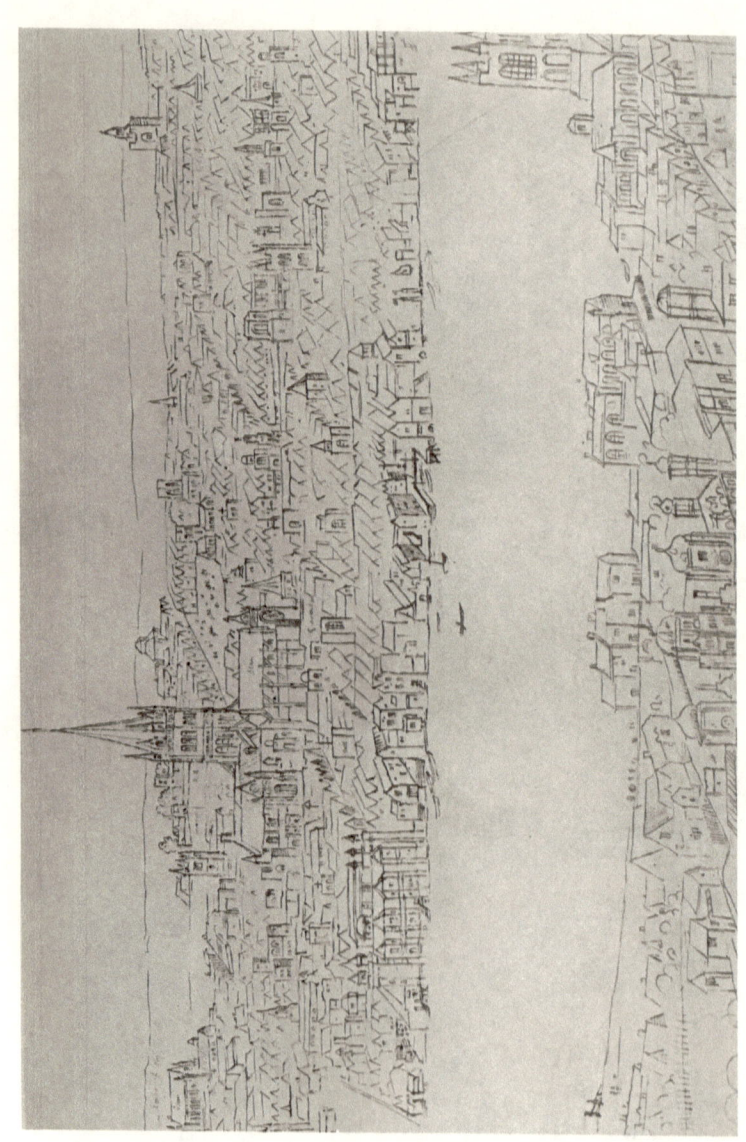

St. Paul's Cathedral. *From the Drawing by Antonie van den Wyngaerde.*

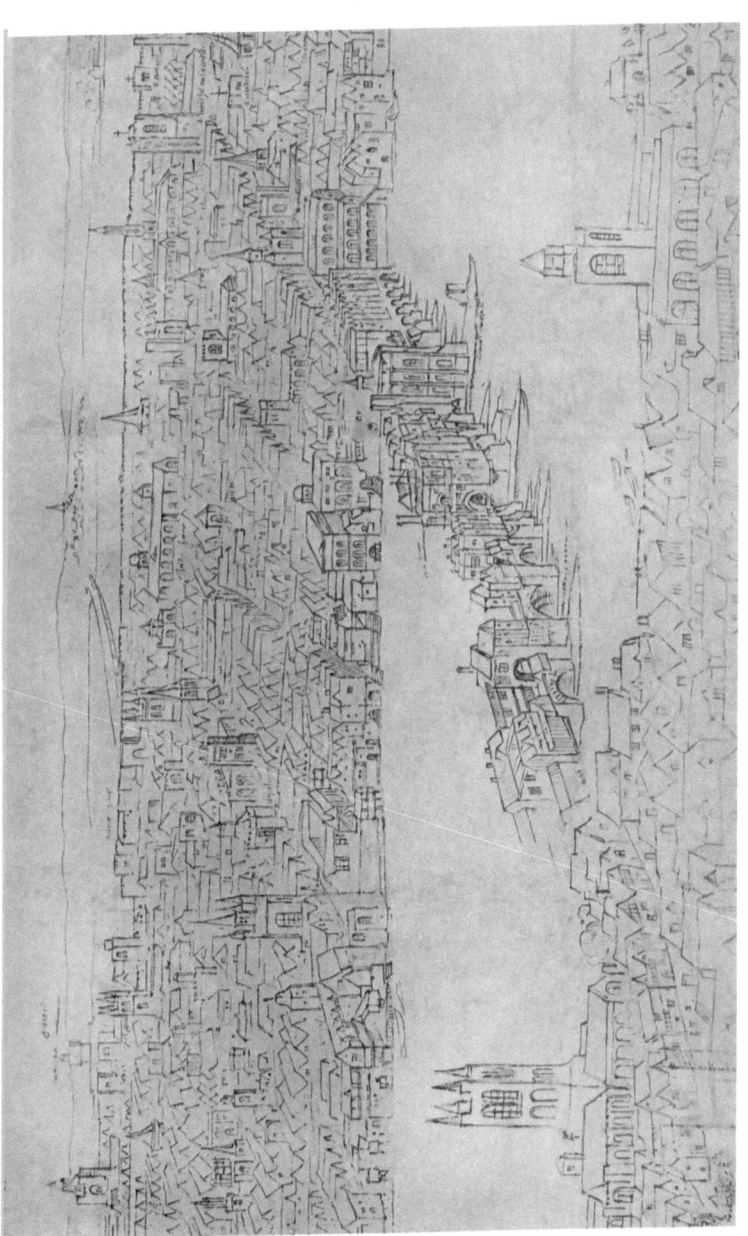

LONDON BRIDGE. *From the Drawing by Antonie van den Wyngaerde.*

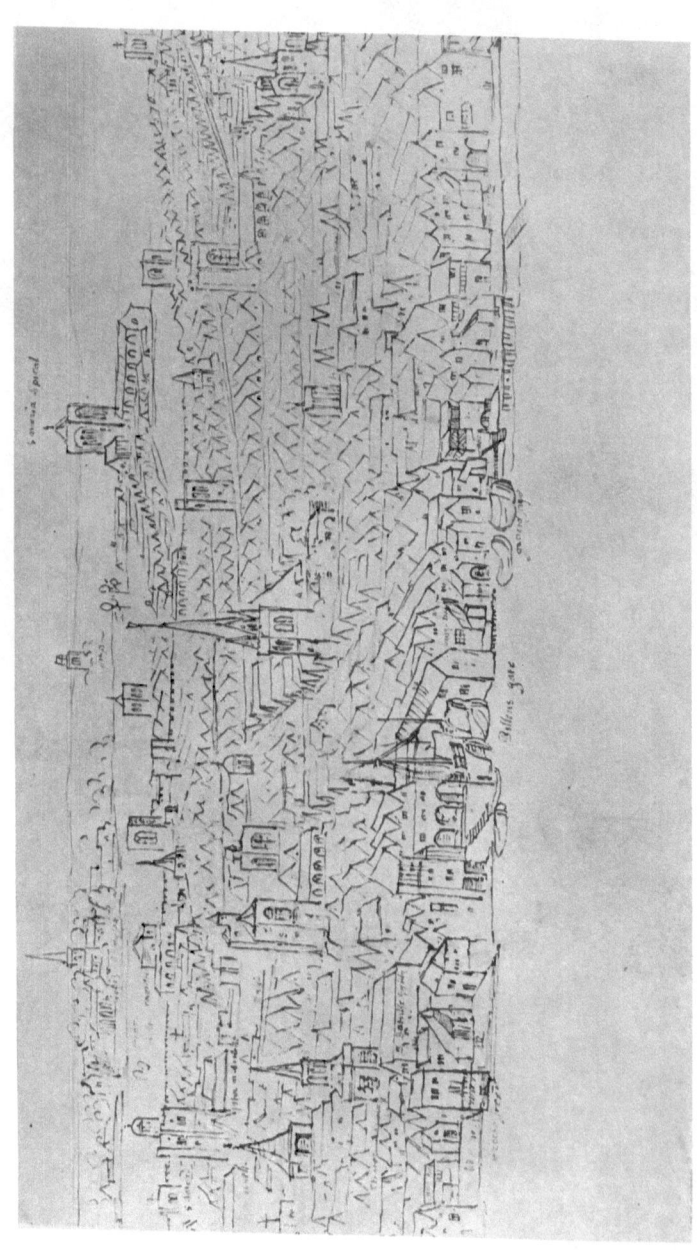

BILLINGSGATE. *From the Drawing by Antonie van den Wyngaerde.*

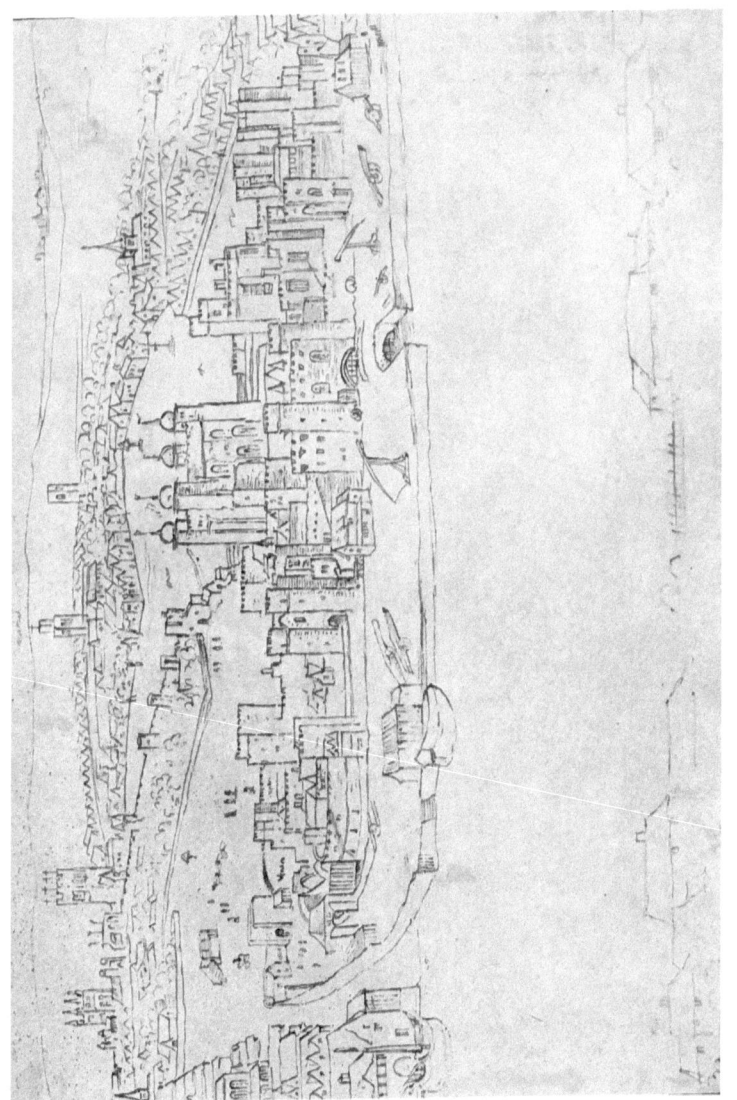

THE TOWER OF LONDON. *From the Drawing by Antonie van den Wyngaerde.*

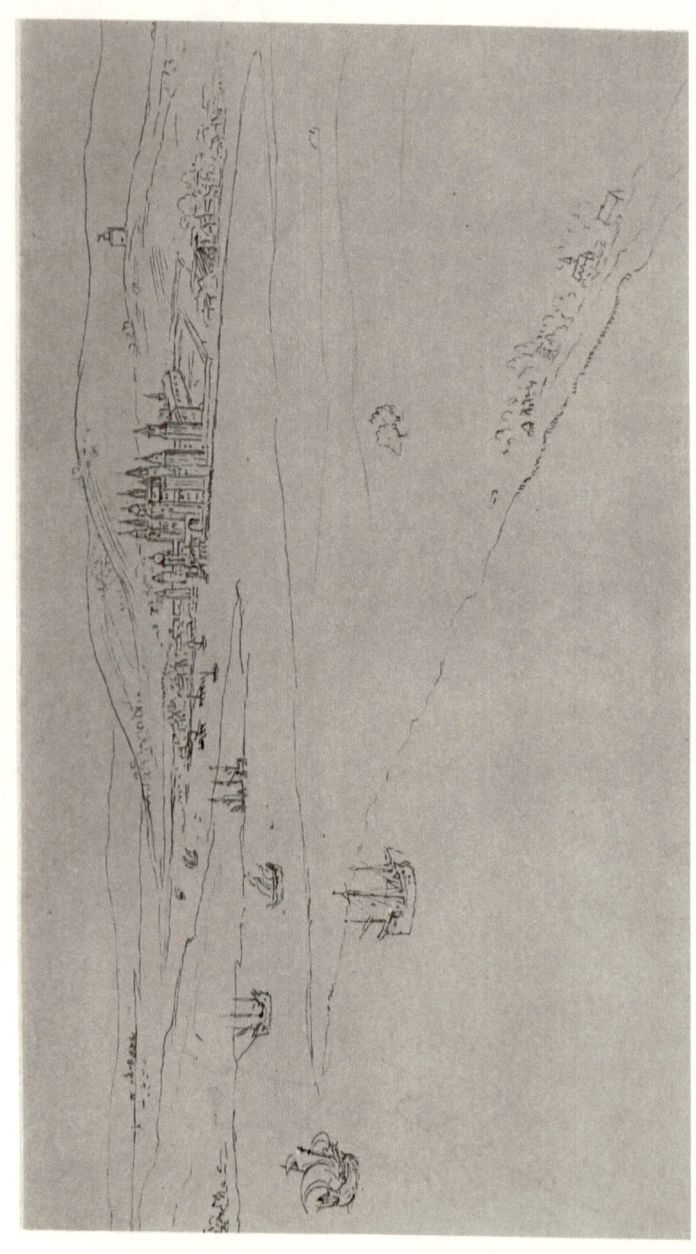

THE PALACE AT GREENWICH. *From the Drawing by Antonie van den Wyngaerde.*

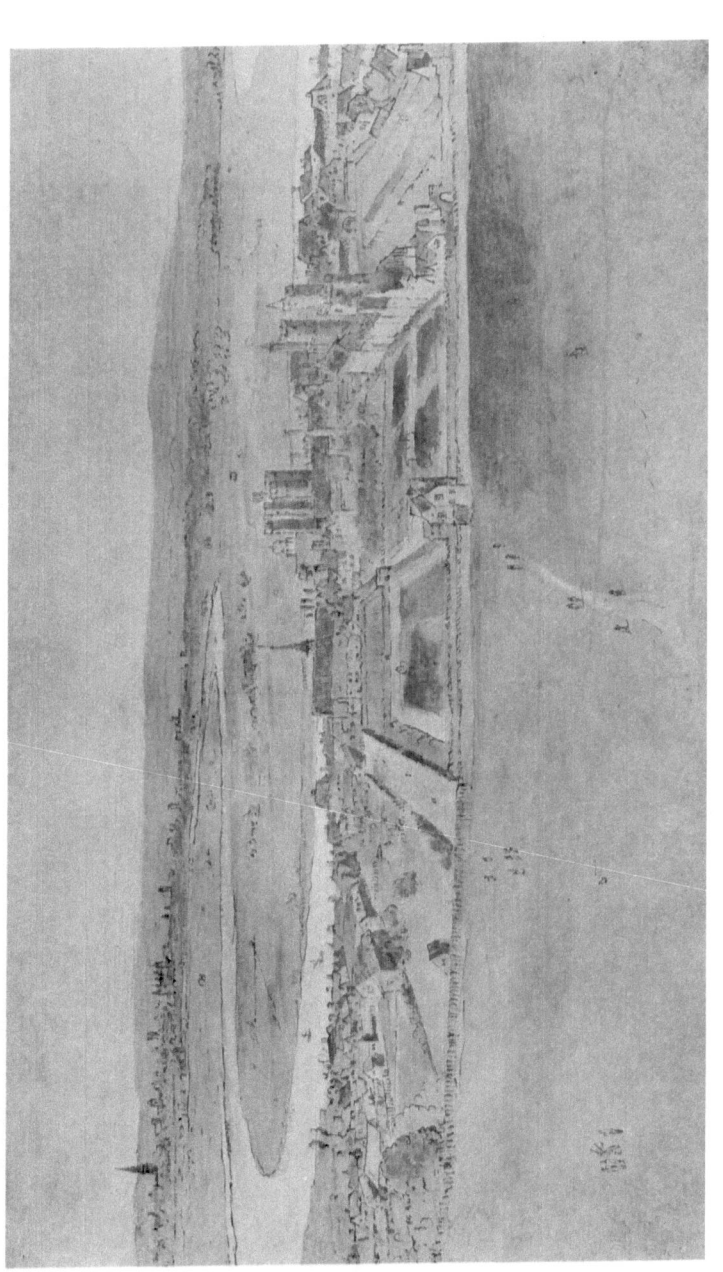

The Palace of Greenwich, from the Observatory Hill, with the Spike of St. Paul's in the Distance.
From a Drawing by Antonis van den Wyngarde. Bodleian Library, Oxford.

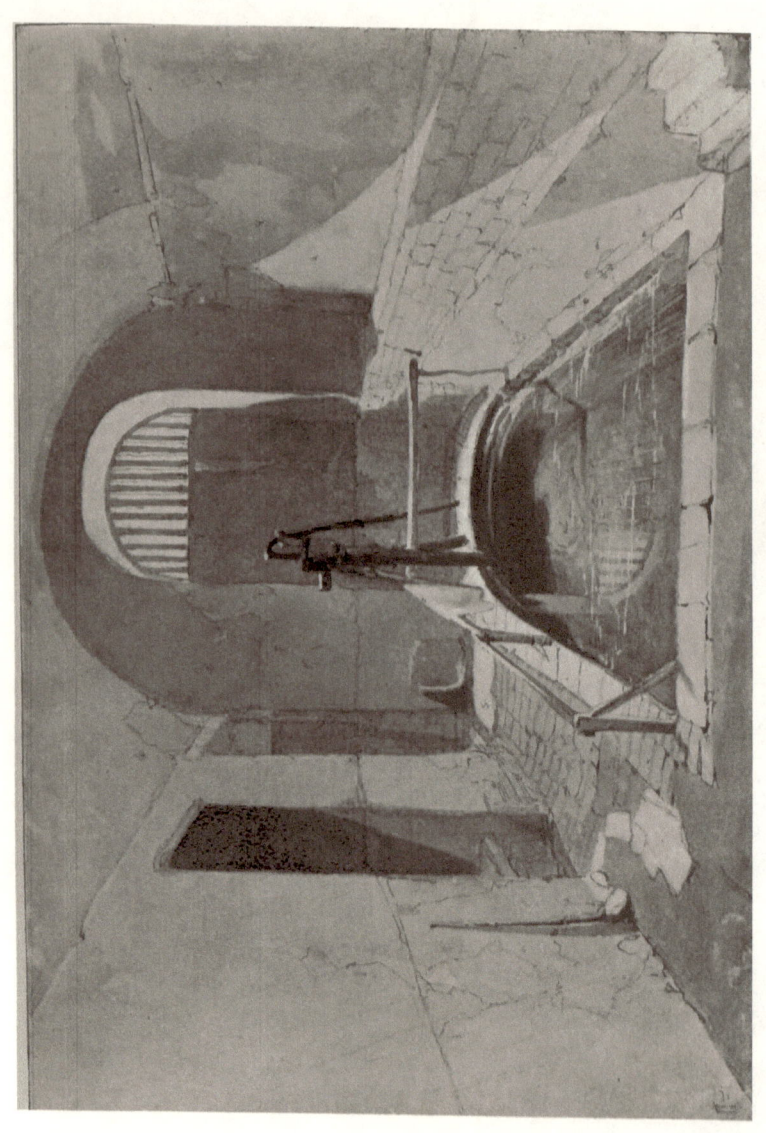

Roman Bath in the Strand, discovered in 1841. *From a Drawing by J. Wykeham Archer, 1841. British Museum.*

BASTION OF THE CITY WALL, IN THE CHURCHYARD OF ST. GILES'S, CRIPPLEGATE.
From a Drawing by J. Wykeham Archer, 1841. *British Museum.*

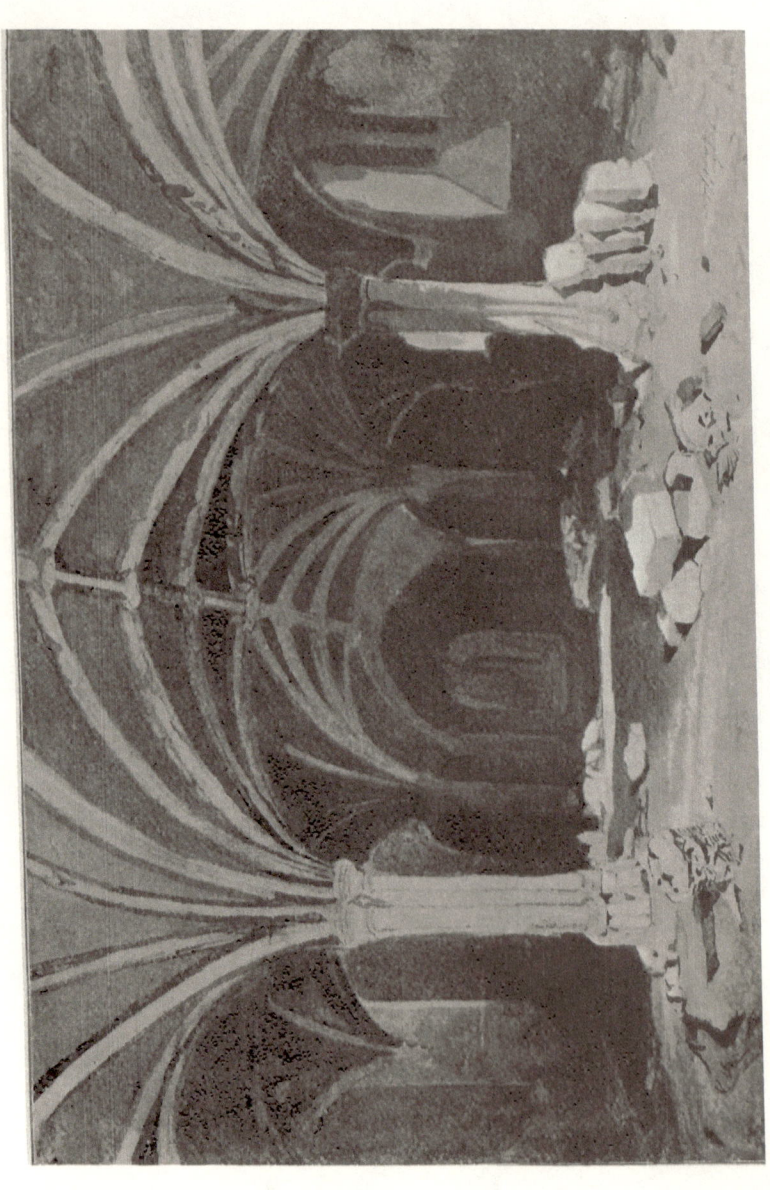

The Crypt of Guildhall. *From a Drawing by J. Wykeham Archer, 1842. British Museum.*

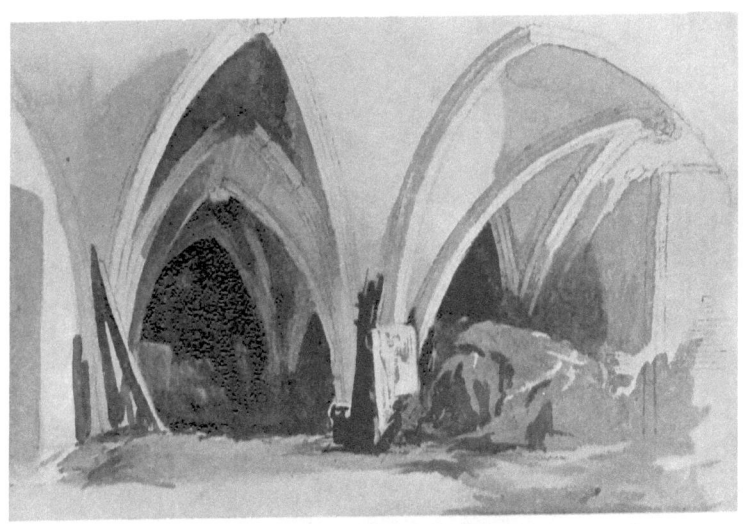

CRYPT OF ST. MICHAEL'S, ALDGATE, DESTROYED IN 1870.
From a Drawing by J. Wykeham Archer, 1841. British Museum.

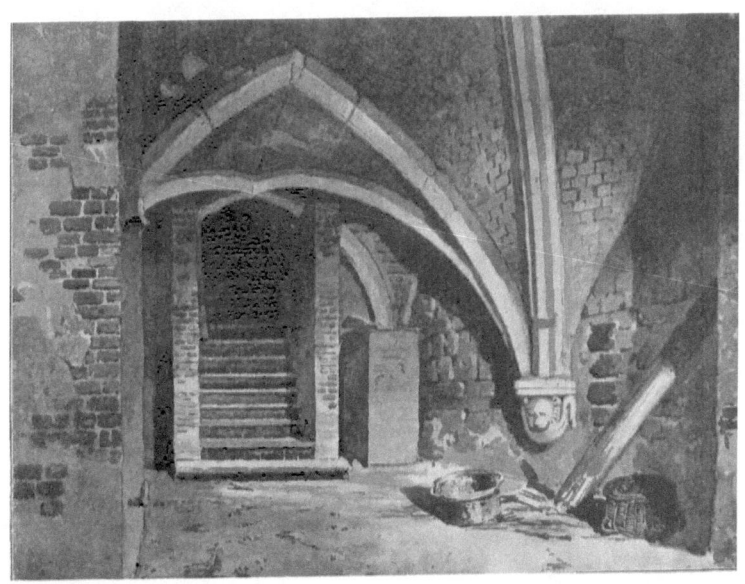

CRYPT UNDER MERCHANT TAYLORS' HALL, DESTROYED IN 1855.
From a Drawing by J. Wykeham Archer. British Museum.

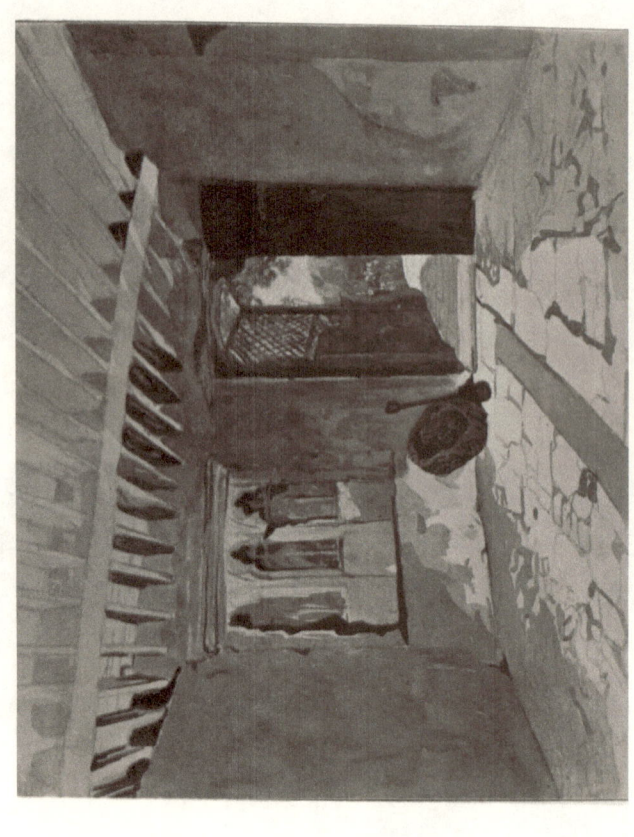

Garden House, Canonbury, built by William Bolton, last Prior of St. Bartholomew's, Smithfield.
From a Drawing by J. Wykeham Archer, 1841. British Museum.

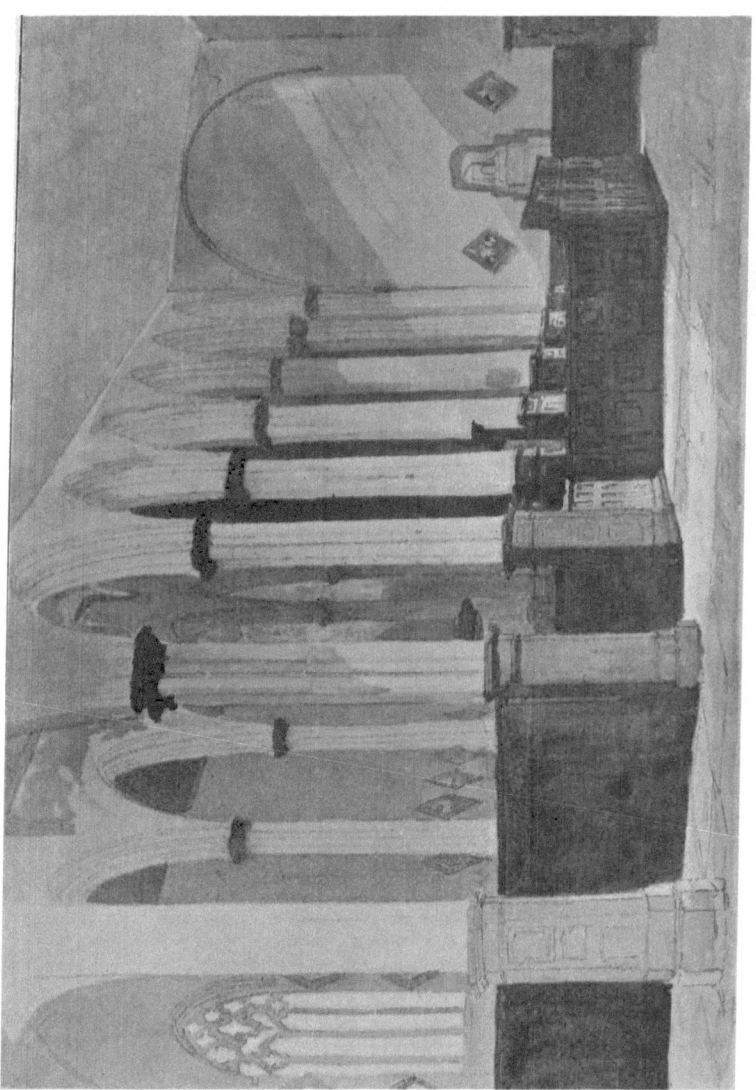

AUSTIN FRIARS. *From a Drawing by J. Wykeham Archer, 1842. British Museum.*

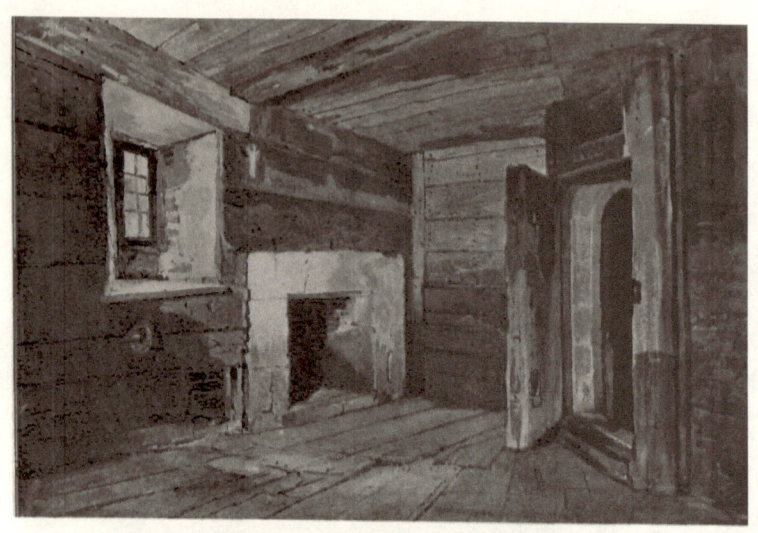

A CELL IN THE LOLLARDS' TOWER, LAMBETH.
From a Drawing by J. Wykeham Archer, 1841. British Museum.

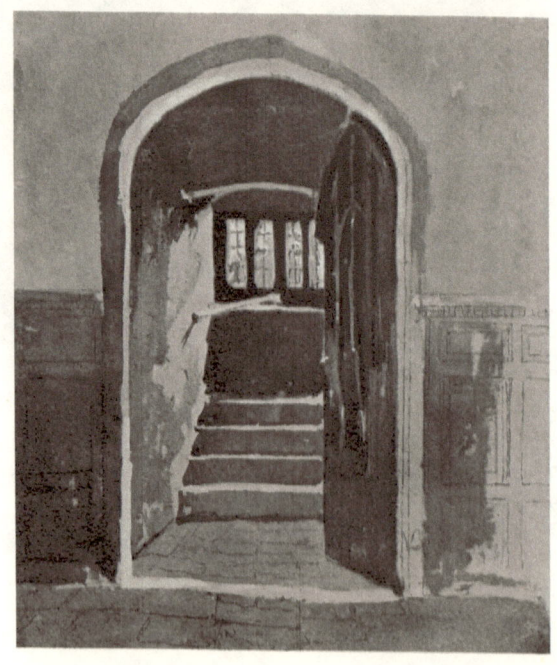

ENTRANCE TO THE LOLLARDS' TOWER, LAMBETH.
From a Drawing by J. Wykeham Archer, 1841. British Museum.

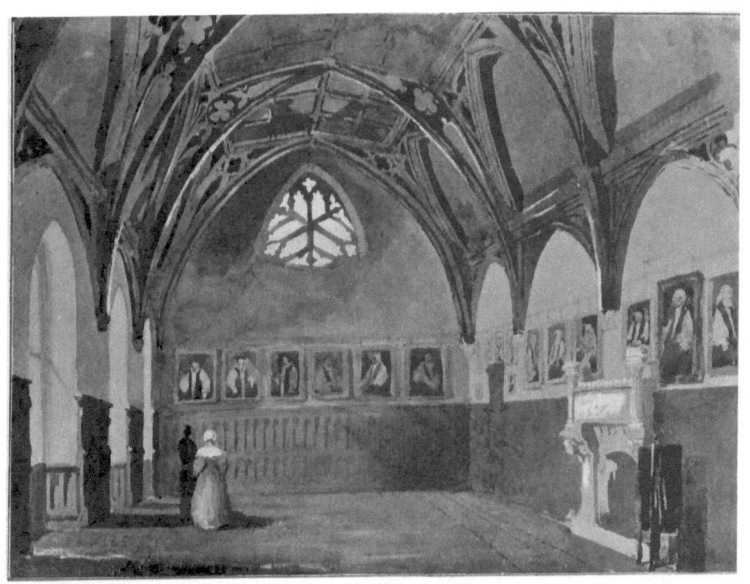

THE GUARD ROOM, LAMBETH PALACE. *From a Drawing by J. Wykeham Archer,* 1841. *British Museum.*

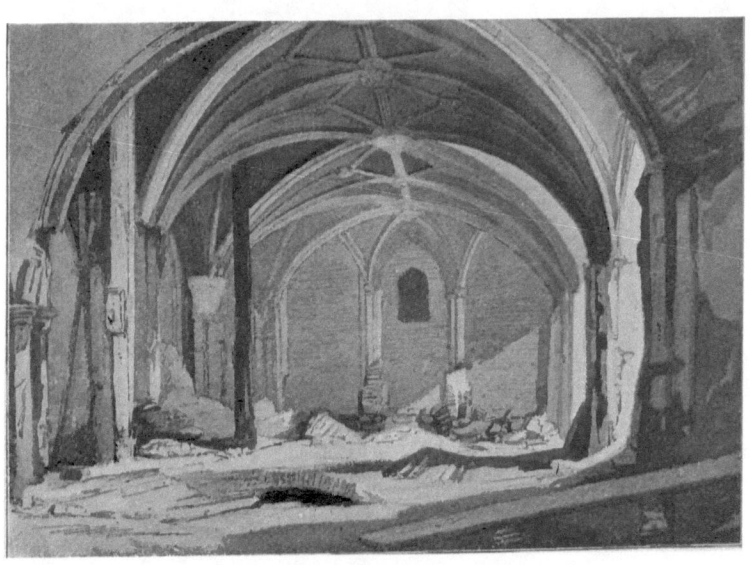

CRYPT OF ST. STEPHEN'S, WESTMINSTER.
From a Drawing by J. Wykeham Archer, 1842. *British Museum.*

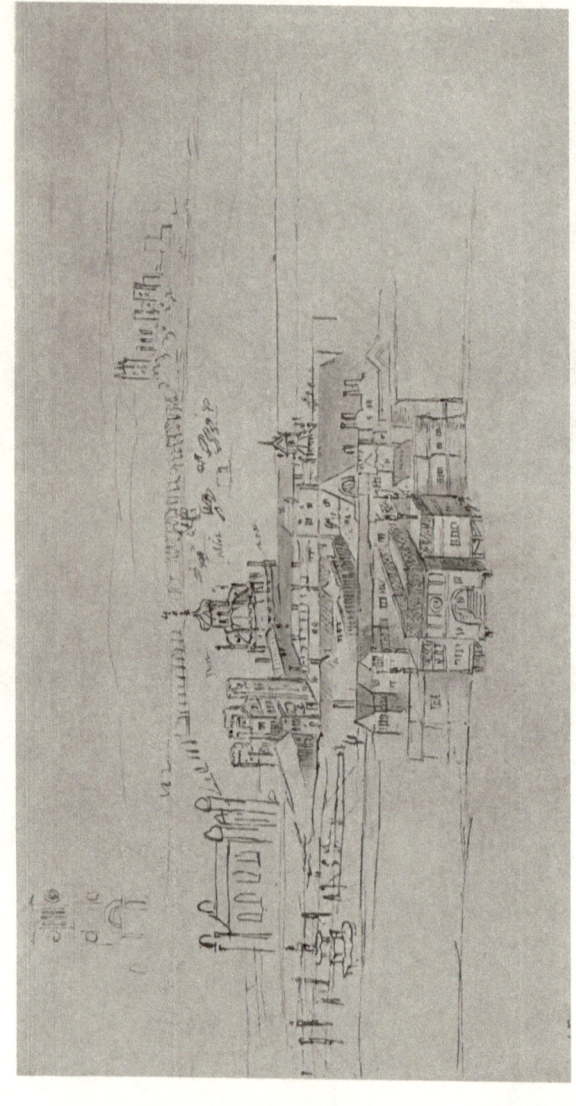

The Palace of Whitehall. *From a Drawing by Antonie van den Wyngaerde. Bodleian Library, Oxford.*

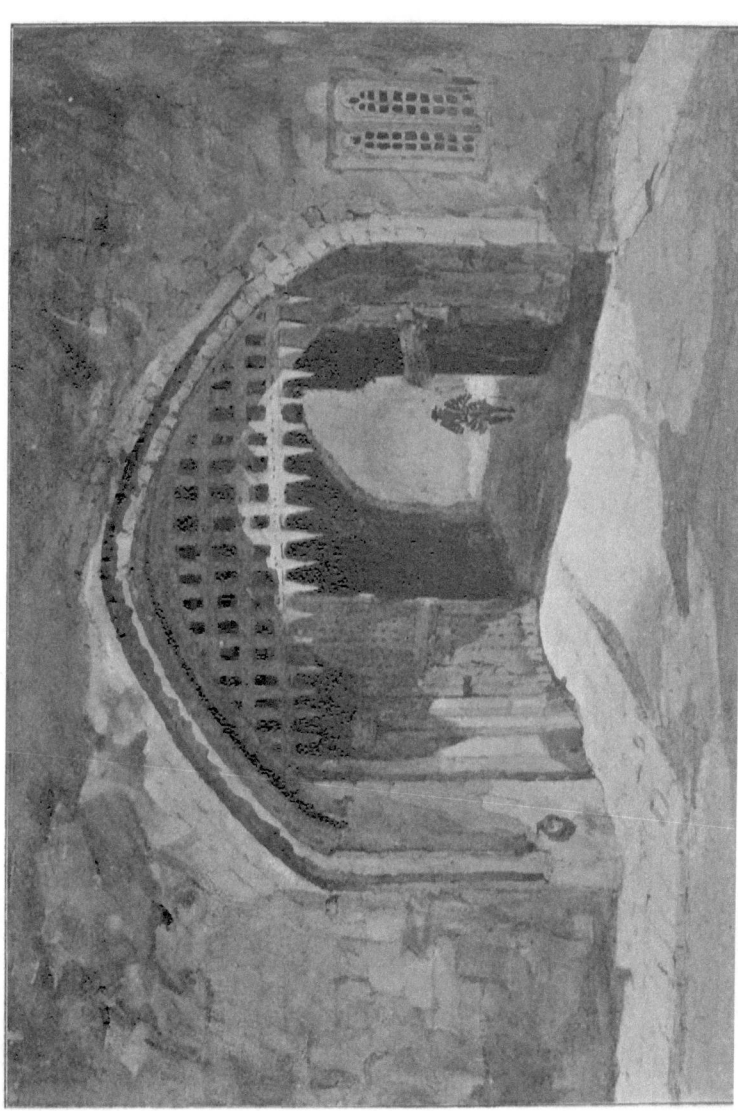

GATEWAY OF THE BLOODY TOWER. *From a Drawing by J. Wykeham Archer, 1847. British Museum.*

Machinery for raising the Portcullis, Tower of London.
From a Drawing by J. Wykeham Archer, 1850. British Museum.

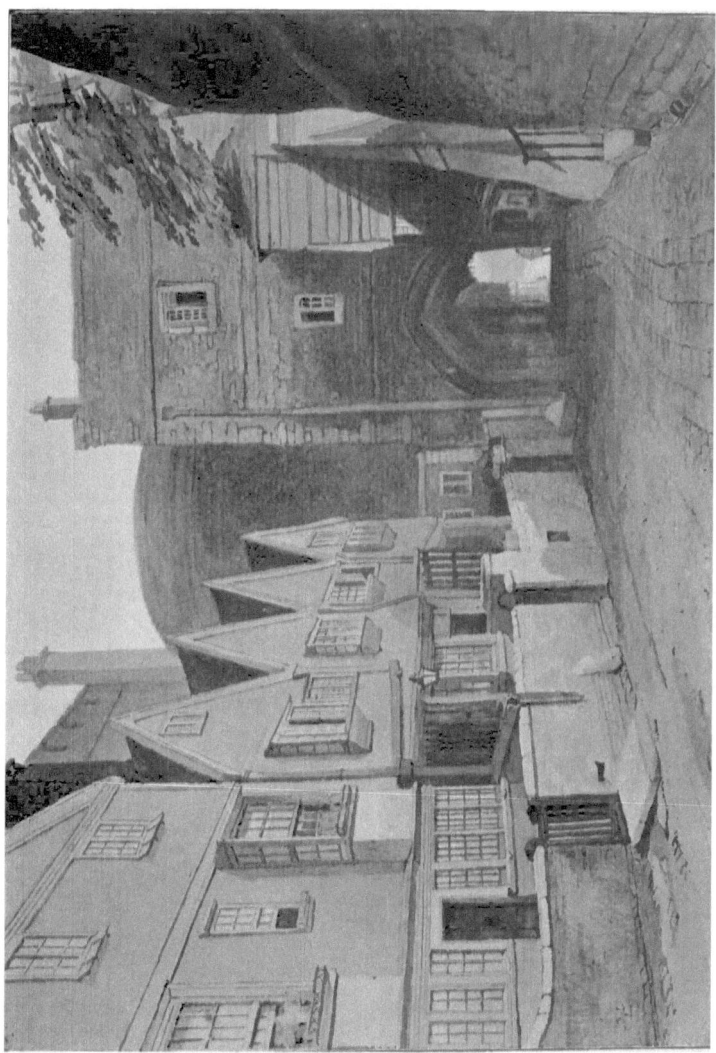

Warders' Lodgings, Tower of London. *From a Drawing by J. Wykeham Archer, 1847. British Museum.*

www.ingramcontent.com/pod-product-compliance
Lightning Source LLC
Chambersburg PA
CBHW020922180526
45163CB00007B/2843